COLLECTING FISHING TACKLE

BY THE SAME AUTHOR

Angling in Art

COLLECTING
FISHING
TACKLE
A Beginner's Guide

TOM QUINN

° THE °
SPORTSMAN'S
PRESS
LONDON

Published by The Sportsman's Press 1994

© Tom Quinn 1994

A catalogue record for this book
is available from the British Library

ISBN 0-948253-68-1

Printed in Great Britain by
Redwood Books Ltd

1995

CONTENTS

ACKNOWLEDGEMENTS

For help with photographs, information and the loan of books (some otherwise impossible to obtain) I owe a great debt of gratitude to Mr and Mrs A.J.T. Guest, Simon Brett, Neil Freeman, Sandy Leventon, Chris Sandford, A.A. Baxter of Farlow's, Hardy's, Sotheby's, Christie's, Bonhams, 'Angling Auctions' of London, and Phillips. Messrs Evans and Partridge of Stockbridge, Hants were also enormously helpful, as were the staff of the British Library.

'The end of Fishing is catching, not Angling.'
Lyly, 1580

INTRODUCTION

Antique fishing tackle is something of an undiscovered country. It is one of the few areas of collecting where the enthusiast still has a very real chance of discovering some rarity – which may have considerable value – in a junk shop, a jumble sale or at a local village fete.

Reels are supremely collectable, for example, and relatively few by great early makers, like Ustonson, have turned up. Yet hundreds must have been made and it is entirely reasonable to think that many more must be lying undiscovered in attics up and down the country.

This is one of the major excitements of collecting antique fishing tackle, but there are many other delights, including the sheer accessibility of rods, reels, line-driers, priests, old creels, floats, flies and landing nets. For the fact is that although interest in antique tackle has developed and grown out of all proportion in recent years it has not reached the stage at which the collector of more modest means can no longer compete. In fact the opposite is true and as the market opens up and more tackle is unearthed, prices, except for the rarest items, remain remarkably affordable.

But what is the appeal of collecting antique tackle anyway? Certainly there are the attractions of coming across a rare and valuable item, but for most collectors there is also the attraction of owning something craftsman-made;

something made using good quality, sometimes rare materials worked by hand; there is also the realisation that the skills which produced early items of tackle have in many cases vanished forever. For the collector who also fishes – and many do – there is, too, the realisation that antique fishing tackle has much to tell us about the history of a sport that if it captivates at all, usually captivates for life.

Many of the objects the collector is likely to come across are also beautiful things in their own right, but with the added attraction – again particularly for the collector who fishes – of revealing the masterful way in which our ancestors coped with problems that, with the coming of modern materials, we simply take for granted.

Modern plastic lines, for example, will float indefinitely and they are made cheaply and easily by industrial processes which involve probably only one technician monitoring a few dials and pressing an occasional button. The silk and horsehair lines of the past, by contrast, had to be woven and twisted by hand or they were made using extraordinary little brass boxes that enabled the process to be carried out a little more effectively.

Or take the example of rods. In the past, cane and other timber was cut and planed to remarkable tolerances to make rods of astonishing quality: fly-rods might be made from wood that had been stored and specially treated for a number of years before the actual rod-making process could even begin.

So craftsmanship is central to the appeal of tackle collecting, but so too is the perception that if we want to understand fully how tackle has developed up to the present day we must try to understand how it changed and developed in the past.

And when we have discovered the remarkable skill with which early rods, reels and other items of tackle were made we may smile at the absurd claims of some modern manufacturers that their carbon rods, for example, are hand-built. What they mean is that the rod itself – the blank – is

entirely machine built, but eyes and varnish have been applied by hand.

In the past the rod itself was cut, planed and tempered only after being carefully and expertly selected from large batches of timbers of many different kinds – hickory, greenheart, lancewood or whatever – and then left for a year or two before being made up, complete with springy whalebone, or cane, tip.

Or take an inconsequential item like the Devon minnow. Today we use them and lose them with little thought, except perhaps when it comes to the cost of replacements, but imagine the work involved in making a seventeenth-century Devon which had to be hand-coloured, stuffed and then sewn in leather and silk?

This book makes no claims to be a definitive study of its subject, which, as research continues both here and in the Unites States, grows ever more complex. Nor is it a book for the specialist, the man who already knows the serial number of every Hardy rod and reel ever made; nor is it aimed at the expert who specialises in collecting rods or reels by particular makers only; it is simply a general introduction which tries to suggest something of the flavour of an endlessly fascinating pastime; a pastime which encompasses the history of an endlessly fascinating sport.

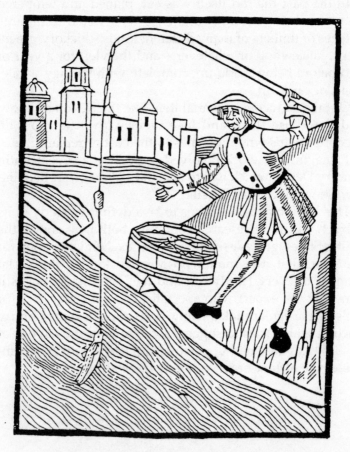

A woodcut from Dame Juliana Berners' *Treatyse of Fishing with an Angle*, the earliest record of angling practice in English.

1

*'Swa swa mid angle fisc gefangen bith
(just as fish are taken with a hook)'*
King Alfred, ninth century

THE EARLIEST TACKLE

Our earliest record of angling practice in England, Dame
Juliana Berners' *Treatyse of Fishing with an Angle*, published
in 1496, makes it clear that those who enjoyed fishing with
rod and line had to make do with whatever tackle they
could make themselves. Rods, lines, hooks and flies were,
at that time, almost certainly home-made and little if any
tackle was being made specifically to be sold.

The *Treatyse* includes illustrations of the various tools
needed to make lines and hooks, and although we cannot
be certain, it is likely that our fifthteenth-century ancestors
simply used a long, one-piece rod cut from the nearest suit-
able tree, almost certainly without a reel and with the line
tied directly to the end of the rod.

It took another two hundred years and a considerable
growth of interest in angling for tackle manufacturing to
have become sufficiently noticeable for it to be mentioned by
writers and commentators. By 1650, though it was still a rela-
tively small-scale, cottage industry, numerous tackle sellers
and manufacturers (usually a manufacturer was also a
retailer at that time) had sprung up to supply the growing
demand for well-made, specialist tackle. Most of these tackle
makers were based in London and although none of the ear-
liest companies has survived down to the present day, we do
know something of the range of items they supplied.

One of the earliest known makers was Charles Kirby who made the first reliable, tempered fish hooks. He began trading in Shoe Lane in the City of London in about 1650 and soon his new hooks were much in demand. Before he arrived on the scene hooks had been soft and frequently unreliable, but the Kirby hook was so successful that his name eventually became synonymous with the very best hooks. Kirby passed his skills on to his children and grandchildren and the firm traded continually until the 1870s. Even today we refer to Kirby-style hooks.

Kirby's reputation was such that his hooks soon began to be copied – or apparently copied – by other tackle makers eager to cash in on his success by telling the world that they too sold Kirby hooks, and in the days when copyright was unheard of, battles and skirmishes ensued.

In the early eighteenth century, for example, Charles Kirby's grandson , also Charles, fell out with another tackle maker, William Browne who had been legitimately selling Kirby hooks for some years, but when Kirby refused to supply Browne after the two men fell out Browne announced that his hooks were now being made by a Mr 'Kirbee', whose hooks were much better than those of Mr Kirby. The transparency of the attempt to deceive is almost laughable but what we know of their dispute provides a real insight into the level of importance tackle-making had achieved by the early eighteenth century.

In fact Kirby so valued his reputation and was so angered by Browne's attempt to steal his thunder that he announced that he had ceased to deal with William Browne and that 'Whereas the said William Browne has pretended to sell fish hooks under the name Kirby, these are to advertise that they are not my hooks, but are an imposition upon the world.'

Few other early makers achieved the reputation enjoyed by Kirby, but other family firms continued in business for equally lengthy periods. Some, like Henry Patten, who had a shop at the Saw and Crown in Holborn, started his work-

ing life as a razor maker and cutler; other makers, including one Gregory (he does not give his other name) who traded at the sign of the Dial and Fish in the Strand, were originally clockmakers. Indeed throughout the early years of tackle manufacture clockmakers, with their skills at brass work, were ideally placed to branch out into the burgeoning world of tackle manufacture.

Among the earliest great tackle makers are Bowness (founded in 1697), Eaton and Deller (founded in Crooked Lane in 1695), John Gillett (founded in Fetter Lane in 1695) and Oliver Fletcher (founded in 1653 at the sign of the Three Trouts in St Paul's). All were in business for decades making the whole range of tackle – from rods, lines and winches to artificial minnows, bait cans and creels – and though little of their output is likely to carry any identification mark, where a particular item does carry a maker's name, it is likely to be valuable. Bowness, Eaton and Deller did, for example, mark their reels with their names (beautifully engraved, one might add, on the reel plate) and such examples do turn up from time to time.

Tackle makers began, in the late seventeenth and early eighteenth centuries, to issue what we would now describe as advertisements. These were sometimes pasted or bound into fishing books or printed as trade cards. Scant though they may be, these scraps of information provide us with an unrivalled glimpse into the past.

A particularly good example of this is to be found in a sheet issued in 1784 by John Higginbotham who declared that he

> Makes all sorts of fishing rods, and all manner of the best fishing tackle, wholesale and retail, and sells the right Kirby's and Ford's hooks, so much admired for their goodness of temper; with the best sorts of swivels, winches, artificial flies, mice etc. Minnow, perch and jack tackle fitted up in the neatest manner. Great choice of curious white silk worm gut, newly come over. The best

sorts of powder flasks, made in metal, tin, leather, horn etc. Best battel gunpowder, shot and flints of all sorts.

There is even a record of a woman tackle dealer – one Sarah Sandon – who traded during the 1740s at the sign of the Compleat Angler in Crooked Lane and sold hooks, rods and nets of 'every size and goodnesse'.

There are also those phantom makers about whom almost nothing is known: makers like Henry Parkhurst who was known to be selling fishing tackle from a shop in Fleet Street in the early 1730s, or Stephen Penstone who sold 'Northern hooks' and brass winches from an address in Drury Lane.

So, by the mid-eighteenth century there were dozens of tackle manufacturers and sellers. Most, though probably not all, were based in London and other major towns and cities.

The best known eighteenth-century tackle maker is undoubtedly Onesimus Ustonson who set up shop in London near Temple Bar, a stone gateway which once stood near the point where modern Fleet Street meets the Strand. Temple Bar, designed by Wren to mark the boundary between the City and the rest of London, has long vanished from London, but it would have been visible from Ustonson's shop which stood at the corner of Fleet Street and Bell Yard, a narrow bustling courtyard which, at different times well into the nineteenth century, housed numerous tackle makers.

Apart from rods and brass winches, Ustonson sold

The best sort of artificial flies, mennow tackle, jack and perch, and artificial mennows and all sorts of artificial baits made upon the said hooks in the neatest manner...gimp, both silver and gold; the best and freshest India weed or grass, just come over; likewise a fresh parcel of super fine silk worm gut, no better ever seen in England, as fine as a hair and as strong as six...all sorts of pocket books for tackle, mennow kettles; fishing

panniers and bags...wicker and leather bottles and many other curiosities in the way of angling.

And with Ustonson we have arrived at the dawn of the era of the great rod and reel makers.

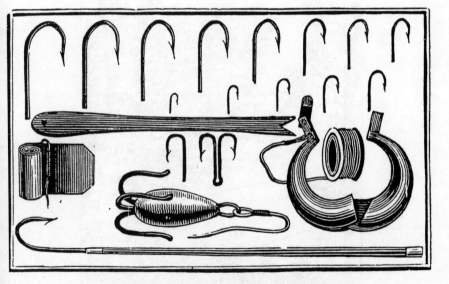

Hooks, a line clearer and a disgorger: an illustration from the eighth edition of Thomas Salter's *Angler's Guide,* published in 1833.

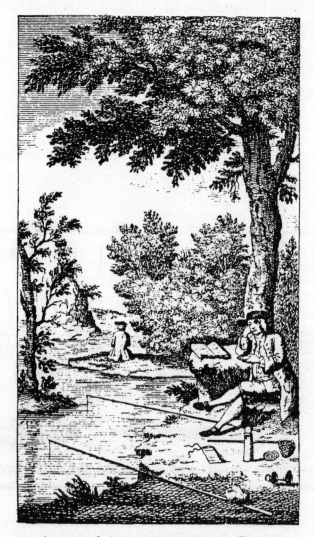

A contemplative man's recreation: an illustration from Izaak Walton's *Compleat Angler*, first published in 1653.

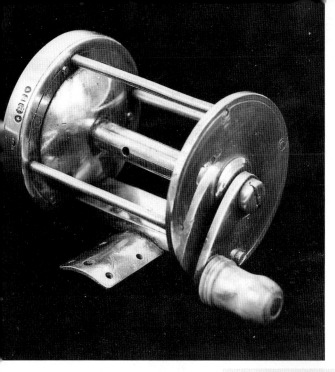

The only known example of a solid silver winch: this remarkable reel is marked 'London' and dated 1851. It has a waisted bone handle, and a foot that was designed originally to hold a leather pad. The pad would help prevent the foot grip scratching the varnished handle on the rod.

PLATE 1

(right) A 2½ in. brass faced Hardy Perfect with smooth brass foot and ivorine handle. This reel has the Hardy Straightline and enclosed oval logos.

(below) A rare J.E. Miller Chippendale tournament threadline casting reel *(left)* made about 1910 and *(right)* an Illingworth No 1 (second model) threadline reel which was probably made in 1908. It is stamped 'Oil Me Please' and has its original leather case as well as two bobbins of Illingworth's own 'special casting line'.

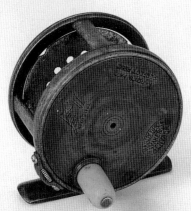

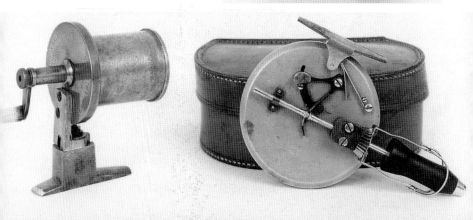

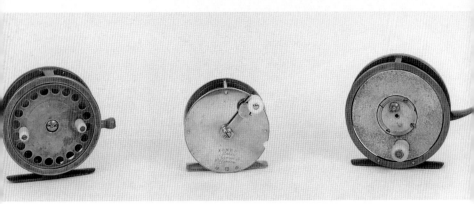

(left to right) An all-brass Decantelle casting reel with twin ivorine handles from about 1900; a Jones of London 3½ in. brass, folding-handle winch engraved with the maker's name from about 1850 and a Farlow 4⅛ in. brass and alloy baitcasting reel stamped with the Holdfast logo and dating from the early 1880s.

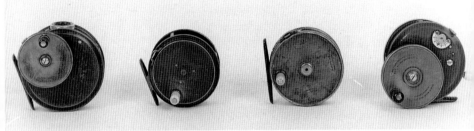

(left to right) A rare Hardy St George 3¾ in. multiplier from the 1930s; a Hardy Special Perfect 3¼ in. alloy trout reel from about 1906; a 3⅜ in. Hardy brass-faced trout reel from about 1900 with Rod In Hand logo and a Hardy Super Silex 3½ in. baitcasting multiplier with casting trigger from the 1930s.

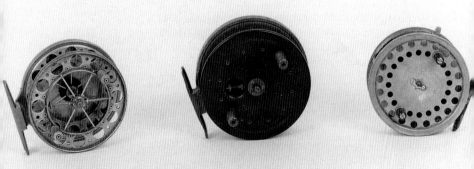

(left to right) A 4 in. alloy Allcock Aerial; a rare Allcock Britannia 4½ in. centrepin reel from about 1915 and a Richard Walker Hardy Eureka 4 in. trotting reel made in 1936.

PLATE 2

2

'You may buy your Trowle ready made ... onely let
it have a winch to wind it up withal.'
Richard Venables, *The Experienced Angler*, 1662

REELS

Reels are almost certain to be central to any general collection of fishing tackle, if for no other reason than many fine examples have survived, particularly from the last half of the nineteenth century and the early part of this century. Reels tend to be more durable than, say, rods or flies; they also come in a wide range of fascinating sizes and styles and they are easier to display than rods, bags and nets.

The history of the reel is a long and complex one, but there seems little doubt that they were not commonly used in Britain until the middle of the seventeenth century. Before that, anglers would have used a rod with the line attached directly to the tip or possibly threaded through one ring on the end of the rod and then simply thrown in a pile on the ground; they may even have attached the line to what is known as a bank runner or trimmer – a wooden spike driven into the bank near the angler. At the top of the spike and turning on a thin spindle would be a bobbin reel (not unlike a large modern cotton reel) round which the line would be wound. These were certainly in use throughout the eighteenth century. If a strong fish was hooked and was likely to run so hard that the angler's line was in danger of breaking, then there would be enough to allow the fish some leeway.

Having said all that it should also be noted that although reels are a relatively recent invention in Europe they were undoubtedly in use in China and probably elsewhere more than a thousand years ago. How they arrived in Europe or whether they were invented and developed independently here is a moot point, but some anglers were certainly using them by the mid 1600s when the second edition of Walton's *Compleat Angler* was published.

The first edition, published in 1653, makes no mention of reels and the reference in the second edition (1655) makes it clear that Walton knew little and probably cared less for these new-fangled things:

> Note also that many use to fish for a salmon with a ring of wire on the top of their rod, through which the line may run as great a length as is needful when he is hooked. And to that end some use a wheel about the middle of their rod or near their hand.

The reference to 'about the middle of their rod' suggests that Walton is reporting what he has heard rather than anything he may have tried himself.

Thomas Barker is generally credited as the first author in English to mention the use of a reel. His book, *The Art of Angling* was published in 1651 and though he does indeed mention 'a hole in the rod to put in a wind' the illustration of the reel mentioned does not inspire confidence. The modern angling writer, A. Courtney Williams said of this illustration: 'Having looked at it for lengthy periods on many occasions I can only say that it seems to bear no resemblance to anything unless it be to a plan for an outside closet!'

More than 150 years after the publication of Barker's book, Thomas Salter, writing in the eighth edition of his hugely popular *Angler's Guide* (1833) advises the fisher that a winch is an essential item of tackle:

> Winches for running tackle: prefer those which are made

to tie on the rod, or to fix in a groove made for the purpose in the butt thereof, as you can fasten such a winch to any size joint, which you cannot do with those that have a hoop and screw: on the winch you use when angling for barbel, chub, perch, pike and bream, keep from twenty to thirty yards of fine platted silk line, called running line or tackle, which you pass through the rings on the rod and join with a slip knot to the gut line.

Instead of the modern bar foot, most early reels were made with a short spike or pillar which was pushed through a specially cut hole in the butt of the rod. Once the spike had been pushed through, a butterfly nut was screwed up the spike until tight against the butt. Alternatively, although this was almost certainly a later development, the reel was fitted with a circular, often leather-lined clamp. The butt of the rod was passed through this and the clamp then tightened. Clamp fitted reels continued well into the late 1800s.

It is something of a misnomer to refer to these very

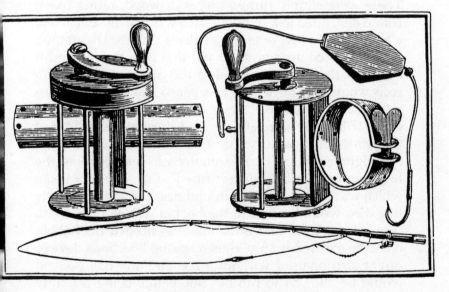

A clamp winch (right) and bar-foot multiplier from about 1830.

early reels as reels at all since at the time they were almost invariably referred to as winches or, in Scotland, as pirns. In appearance early winches are very much like modern multipliers. With their axles held securely at either end they presented fewer technical difficulties for their makers than the kind of later fly reel or centre pin reel which had an open-ended axle on which the narrow spool would sit.

It has long been assumed that the multiplier was invented in America. In fact it was simply a variation on the straightforward early winch with an offset handle and sufficient gearing to ensure that one turn of the handle would retrieve many more inches of line than was possible with a centre fitted, plain winch handle.

Early reels were almost invariably made in brass, with horn or ivory handles and their primary function was twofold: to increase the range at which the angler could fish and to assist him when it came to playing fish that were too big simply to be held on a fixed line and then dragged to the bank.

Extra line was sometimes held on so-called thumb reels. These were simply turned pieces of wood, rather like a cotton reel, fitted to a spindle which was in turn attached to a ring which fitted over the angler's thumb. The 'thumb reel' would be used on the hand that held the rod and it obviated the need for a reel-to-rod attachment. Thumb reels would also have been cheaper to make and buy than more conventional reels. They were certainly in use by the early 1700s and were still around during the middle of the nineteenth century. Another oddity in use during the eighteenth and early nineteenth century was the bank runner – a bobbin reel fitted to the top of a spike which was driven into the ground near the angler and the line then wound round to the bobbin. When a good fish was being played and extra line was needed the bobbin could be allowed to turn, thus releasing line. Such devices might also be used without a rod and any fish hooked would be allowed to run out line before being carefully hand-lined to the bank.

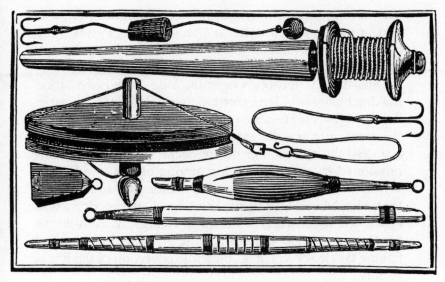

A selection of early nineteenth-century tackle.

Pirns were large, usually wooden trolling reels mostly used in Scotland for salmon and elsewhere perhaps for pike and other large fish. They are rare today and highly collectable.

Another oddity which is rather outside the general trend of reel development is the butt-fitted reel. This was incorporated into a handle (much like a short rod handle), the end of which fitted on to the end of the butt of the customer's rod. The butt-fitting reel was being sold by Hardy's and probably one or two other companies during the last decade of the nineteenth century.

If the butt and thumb reels of eighteenth and nineteenth century England are mere curiosities of tackle development the same can certainly not be said for reels made by the firm of Ustonson who are central to the development of the reel and indeed of the tackle trade in Britain.

We know a great deal about Ustonson partly because the company made tackle for members of the British and other Royal families and partly because they were in business for

such a long time. Though there were changes of address and of name – eventually to Ustonson and Peters – the company continued in business from the late 1760s or early 1770s until 1855.

Oneisimus Ustonson bought the long-established tackle making business of John Herro (latterly Robert Hopkins) in Bell Yard just off Fleet Street sometime in the mid 1700s. By this time, such was the quality of his tackle, Ustonson had attracted the attention of the aristocracy and he was commissioned to make tackle for, among others, the Earl of Winterton. By 1824 the firm's reputation had so increased that Mrs Maria Ustonson, then head of the firm, was appointed royal warrant holder to George IV. And it was for George IV that Ustonson built the magnificent cased fishing tackle set which is still in the collection of the Royal Family.

The leather covered, velvet lined case (3 ft long, 9 in. broad and 3 in. deep) contains a fly book, an ivory cast winder, a landing net, engraved brass winch, and a rod with spare tops. The brass winch is undoubtedly the centrepiece of the collection and it has all the hallmarks of Ustonson's extremely fine workmanship with its turned pillars and plates and beautiful engraving.

Ustonson winches, both ordinary and multiplying, were engraved probably only when they were bought by members of the aristocracy or the Royal family (Ustonson continued to supply tackle to William IV and Queen Victoria), but one or two plain examples have turned up. These are clearly identifiable as Ustonsons by the U stamped on the base of the brass foot.

Another great maker who began work in the eighteenth century and lasted well into the nineteenth was Bowness and Chevalier, who traded from a shop just a few yards from Ustonson's original premises in Bell Yard. They made brass winches and reels as well as other items of tackle, but as with Ustonson only a few of their reels are marked. Eaton and Deller who started out as plain Eaton from an

address in East Cheap, London, began making reels and rods in 1790 and they were still in business in 1951!

By the mid 1800s there had been an explosion in the number of manufacturers of reels and other items of tackle and vast changes in the range of modifications and styles of reel and rod. New materials were being incorporated, particularly by innovative makers like Farlow's who started life in 1840 and are still trading today.

Farlow's first began trading from an address in the Strand. The company was so successful that the son of the founder was able to send his son, Charles, to the great public school at Charterhouse. Charles became an engineer and his knowledge of metals and construction undoubtedly helped the company stay ahead of the competition. He invented the Billiken reel which broke a number of casting records and, in 1911, was probably instrumental in helping to buy land in Croydon, a dozen or so miles south of central London, where the company could manufacture its own tackle.

Farlow's made plain and multiplying brass winches in sizes from 1¼ to 3½ in. as well as wooden reels. They also sold Aerial and Malloch reels stamped with their own name. By the early 1900s they were selling aluminium fly reels and winches, sea reels, Aerial trotting reels and many other brand name reels including the Regal Salmon Reel (sold between 1930 and 1940), the Pelican Sea Reel (1912 to 1915) and the Cooper Multiplier (1910 to 1913).

Perhaps the greatest Victorian reel invention was the centrepin, a reel that ran on an axle pinioned at one end only, unlike the multiplier or plain winch which had an axle attached to plates at either end. Early centrepins were made of wood, usually walnut or mahogany (these woods tended to warp and swell less when damp than other woods) and they were named after the place where they were first made in any numbers: Nottingham.

So long as they were carefully varnished and kept perfectly dry, these light sturdy reels worked well, but

prolonged damp could make even the best begin to warp and swell thus reducing the free-running of the spool. To reduce this tendency, brass stars (sometime straight bars) were screwed to the back plate to reduce any movement caused by water. Nottingham wood reels with brass star-backs eventually became known simply as starbacks. Eminently collectable – largely because they are still common in sizes from about 2 in. to about 4½ in. – these starbacks are typical of the kind of reel that kindles the first spark of a new collector's enthusiasm.

It is important to remember that though much of the early tackle-making business was concentrated in London, the provinces quickly caught up and in Scotland, where of course much of the best game fishing was and still is to be had, tackle making developed quickly as the nineteenth century progressed.

Among the great Scottish reel makers were Playfair who was in business from 1820-1955, Arthur Allen (1870-1978) and, perhaps the best known Scottish maker of all, P.D. Malloch (1875-1981) whose side-casting reel was the most popular fore-runner of the modern fixed spool reel.

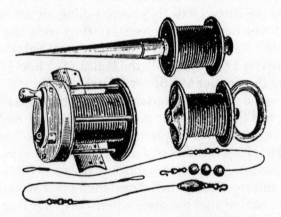

Mid nineteenth-century bar-foot multiplier
(note the off-set handle), bank runner *(top)* and
thumb-reel.

Malloch's side caster had a two-position drum – it turned through 90 degrees to move from the casting position to the winding in position – which enabled the user to cast light baits great distances. The drum wound in normally, but when the angler wanted to cast he turned it until it was side on to the rings on the rod. The flange on the casting side of the drum had a slightly convex shape which meant that the line would peel off over it with little friction. Once the cast had been made the drum swivelled back to the wind-in position.

Much simpler than the later threadline reels, the Malloch's only disadvantage was relative slowness in use. Malloch side casters are eminently collectable, but reels using the same principle were made by a number of other manufacturers including Farlow's who made the Turntable Reel (from 1924-1937), and the Brownie – named after its inventor, manufactured by Milward and sold for just a few years in the early 1920s. The idea of a reel with a spool that would turn sideways to permit easy casting and yet retain all the benefits of playing a fish directly on a drum and with no gears was so compelling that as late as 1950 such reels were still being made – one such was the now rare Howban reel made by a Birmingham company called Howell & Co.

Winches and other early reels were not designed specifi-cally for fly fishing and indeed much early fly fishing would not have involved the kind of techniques we under-stand as fly fishing today. The ability to propel a specially tapered line 15 or 20 yards using a carefully balanced line and rod is of relatively recent invention – probably not much earlier than the latter half of the nineteenth century. Before that, a long rod would have been used to dibble arti-ficial flies (or naturals) on the water either from the bank or trailed behind a boat.

Certainly bigger reels had always been used for bigger fish – thus salmon and pike reels might be 3½ or 4 in. in diameter, while reels designed for fishing brooks and streams might be only 1¼–2½ in. models.

More specialist reels began to develop towards the end of

the nineteenth century as fishing itself became increasingly sophisticated. Brass and rosewood reels began to appear together with reels made in lighter alloys; reels were fitted with two handles, with brake mechanisms and with line guards; crank handles gave way to handles fitted on the plates or flanges of the reels; ventilated drums (holes cut to reduce weight and to help shorten the time it took for the line to dry and thus prevent rotting) began to appear and, finally, from the mass of burgeoning tackle makers came a few greats whose names are legendary: Illingworth, Allcock and Hardy, the latter probably the best known tackle maker in the world.

Illingworth's great contribution to reel making was the invention of the first recognisably modern fixed spool reel. Hardy's great contribution, apart from the sheer quality of so many of their rods and reels, was the idea of treating a reel as a piece of precision engineering and of using ball bearings in reel axles.

Let's start with Illingworth. The problem of casting light baits any distance had dogged tackle makers for decades. With winches and other early reels the bait would have to be heavy enough to turn and maintain the motion of the brass drum on the reel in order to pull off sufficient line to achieve any distance. By the 1880s whippy cane rods had obviated the need for such a reel in the fly fisher's world, but among the growing band of coarse and sea fishers the problem remained.

Alfred Illingworth invented his threadline spinning reel in about 1905. Instead of the drum of the reel turning (as it did in winches and other reels) the Illingworth threadline had a 'wire flyer' (an early form of the bale arm) which picked up and then wound the line around a stationary spool. The popularity of Illingworth's invention was such that dozens of imitators were soon bringing out their own versions of the great reel, the Bercol (1930s), for example, and the Allcock's Stanley which was certainly in production by 1920. But not to be outdone, Illingworth himself

continued to modify and improve his design during the first decades of this century. The final version of the Illingworth, No 5, looks virtually indistinguishable from a modern fixed spool reel.

Illingworth No 1 reels are among the most sought after of all old fishing reels, but other highly collectable early fixed spool reels include Foster's New Excelsis, produced during the 1930s with a brass frame and alloy spool and Allcock's Felton Crosswind (1930s). Perhaps the most recent highly collectable fixed spool is the Young's Ambidex, a well engineered reel that first appeared in the early 1940s and was manufactured in a number of versions.

The range of collectable fixed spools is vast, but names well worth looking out for are Allcock's Kastlite (1940s) and Kasteasy (1950s), the Canute (made by the Canute Engineering company in the 1950s), the Allcock's Silver Superb (1950s), Milward's Magnacast (1930s) and the Leighton, a Bakelite fixed spool reel made in the 1940s.

Alnwick is a small town in a remote part of Northumberland, but among its most famous sons must be the two Hardy brothers who set up their tackle making business there in 1872. William and John James Hardy were both engineers who made guns and cutlery. These sides of the business did well, but the brothers quickly found that their fishing tackle business was likely to prove far more profitable. As split cane rods were then taking over from hickory, ash and greenheart, the Hardy Brothers offered what were already among the very best of the new designs. Indeed in the early days the Hardy brothers rather neglected their reels, which were pretty much run of the mill affairs, and concentrated instead on the market for the new cane rods. By the 1880s the third brother, Foster, had joined the firm and in 1888 it was Foster who patented the idea of using ball bearings to improve the company's reels. Ball bearings were central to the success of the most famous Hardy reel in the world : the Perfect, which was first introduced in 1891.

Such was the ingenuity of the brothers that within a few years of its introduction the Perfect had been made in several versions – the first Perfect had a simple centre pin construction where the 1896 version had a two piece frame connected by nickel pillars. This ensured a much stronger, smoother running and longer-lasting reel. An original Perfect is perhaps the most sought after of all reels and such is their rarity that prices can reach dizzying heights, certainly several thousand pounds.

The earliest Perfects were brass with a special bronzed finish, but the brothers were always quick to adopt new lightweight materials and by the early years of the new century they were using lightweight alloys for many of their reels. Perfects were at this time being made in wide and narrow drum versions and like most reels of the time they were fitted with ivory or horn handles, though later models have handles made from ivorine, a man-made substitute which has many of the characteristics of the natural material.

The very earliest Hardy reels are instantly identifiable by the trade mark stamped on the handle plate. This shows a hand holding a rod and reel with the line running off the reel and under the rod hand. This logo ceased to appear on all but a few reels after 1903-5. Some Perfects were being made in alumin (an early alloy) even before the end of the nineteenth century, such was the eagerness of the Hardy brothers to adopt the latest materials and manufacturing techniques. They were effectively revolutionising one of the most conservative areas of fishing tackle manufacture.

Among the great and highly collectable Hardy reels are the Bougle (made from 1903 until 1939), the Hercules (from about 1880 until 1904), the Silex (introduced and continued, in varying forms, until 1971), the Uniqua (1903 and in various forms until 1959), the St George (1911 until 1983) and the Field (1879 and in various forms until 1907).

Hardy also made fixed spool reels, including the Altex

and the Match Fisher (1936-1939) and sea reels for the UK and export markets. Sea reels included the Ocean (1894 to 1911), the Farne series of reels (1896 until 1939), the Longstone series (1905 until 1959), the Natal (for the South African market – 1923 until 1948), the Hardy Zane Grey commissioned originally by the author and big game fisher whose name it bears (1928 until 1957) and the Coquet (1911 until 1922).

The company also made a range of multipliers including the Cascapedia (1932-1939), the Hardy Jock Scott (1952) and the Elarex (1939-1964).

Most Hardy reels were modified and updated if they continued in production long enough but almost all the early versions of the famous reels are interesting and highly collectable, although inevitably the Perfects in all their guises and modifications command most attention. Perfects come in a bewildering range of styles and varieties – there are the early Perfects, wide and narrow drummed versions, the Mark II (and Mark II duplicated) and the Mark III. There are also Perfects with silent checks. Most Hardy reels are clearly marked and if a reel is obviously fairly early and marked with the Hardy name (as they almost invariably are), it is well worth collecting.

As a general rule (though this is by no means always the case) Hardy sea reels and multipliers are of less interest to the collector than early fly reels. The Perfects though by no means the rarest Hardy reels, tend to be among the most expensive largely because the reel has continued in production for such a long time and also because very early models are rare. Only two or three examples of the original Perfect in its 2¼ in. form have, for example, ever come to light.

A relatively rare reel like the Hardy model marked simply 'Fly Reel', though valuable because of its rarity, could not compare in terms of collectability with an early or unusual example of one of the more famous reels – like the Perfect.

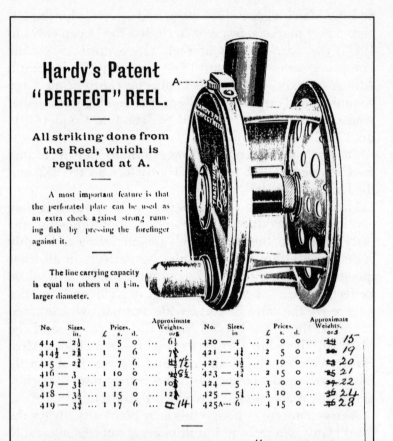

Hardy's Patent "PERFECT" REEL.

All striking done from the Reel, which is regulated at A.

A most important feature is that the perforated plate can be used as an extra check against strong running fish by pressing the forefinger against it.

The line carrying capacity is equal to others of a ½-in. larger diameter.

No.	Sizes. in.	Prices. £ s. d.	Approximate Weights. ozs	No.	Sizes. in	Prices. £ s. d.	Approximate Weights. ozs
414	2½	1 5 0	6¼	420	4	2 0 0	~~19~~ 15
414½	2¾	1 7 6	7½	421	4¼	2 5 0	~~22~~ 19
415	2¾	1 7 6	~~8½~~ 7½	422	4½	2 10 0	~~23~~ 20
416	3	1 10 0	~~8½~~ 8½	423	4¾	2 15 0	~~25~~ 21
417	3¼	1 12 6	10⅝	424	5	3 0 0	~~37~~ 22
418	3½	1 15 0	12⅝	425	5¼	3 10 0	~~36~~ 24
419	3¾	1 17 6	~~□~~ 14	425A	6	4 15 0	~~#~~ 28

Instructions for Cleaning and Oiling the "Perfect" Reel.

To dismount the Reel—Remove with a coin, the small left handed screw in centre of plate. Hold the line drum, Fig. 3, with the left hand, while with the right unscrew the revolving plate, Fig. 2, by turning handle to the left; when the plate is unscrewed the drum may be taken out. All should then be wiped clean, and the parts oiled. To put Reel together, replace the drum taking care that the end of line is clear of guard, and screw down revolving plate; replace small left hand screw.

AUCKLAND, October, 1894.

Having fished once with one of your "Perfect" reels I should not care to use any other. They are *the* reels for the varied N.Z. fishing. C. E. S. GILLIES.

The most famous reel in the world: these two pages show an advertisement for the Perfect from Hardy's 1899 catalogue.

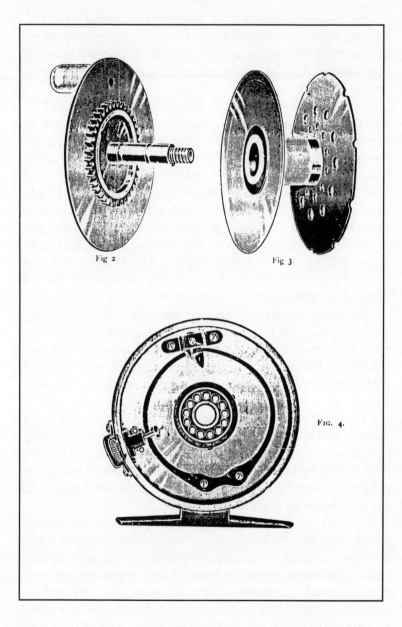

Fig 2

Fig 3.

FIG. 4.

31

The history of the Perfect is worth examining in detail: first because it is without doubt the most famous of all reels and second because in its many forms it encapsulates the engineering skills of a firm that has come to be synonymous with top quality tackle.

The Perfect first appears in Hardy sales literature in 1891 and it was the use of ball bearings that made the reel such an important innovation. The bearings were housed in a race at the base of the spindle. Like almost all reels produced at the end of the nineteenth century the early Hardys were all brass, but realising the potential of new alloys the Hardy brothers quickly incorporated them into the design of later models. At first brass was kept for the face of the reel and when the natural caution of the angling public had been reassured by the fact that alloy parts did not fail, the company was able to introduce Perfects and other models of all-alloy construction.

Most early brass reels made by Hardy's and other manufacturers did not have the bright brass finish we see on most of them today – they were in fact bronzed, a process which left them with a dull, gunmetal finish which would clearly reflect and flash less than brass when the reel was in use.

In 1897 the Perfect narrow drum reel appeared on the market and it was made entirely from what the company called alumin. As the new alloys came in, so too did materials for the reel handles. These had been made of ivory, but a new man-made substance called ivorine soon began to replace the more traditional material.

Many of the early Perfects are stamped with the initials of the individual workman and for obvious reasons these are now particularly keenly sought by collectors. The fact that individuals took this level of responsibility for their work suggests the value Hardy's as a company placed on craftsmanship; of course it also tells us just how far the tackle making business had moved on from the days when it was a sideline carried on by clockmakers or cutlers who,

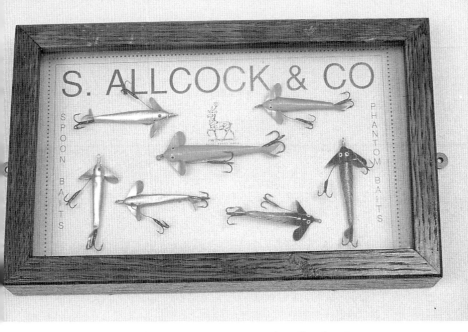

A display case showing Devon minnows by Allcock & Son.

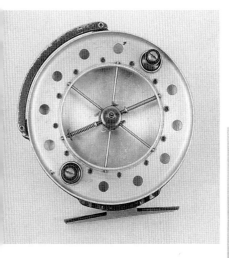

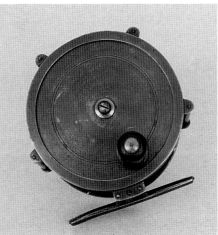

(left) A top-quality Allcock Aerial: generally agreed to be the best trotting reel ever made.

(right) A fine, all brass, raised pillar reel by the London maker Alfred and Sons who were in business from 1856 until 1903.

PLATE 3

A nineteenth-century line twister in brass with ivory handle.

PLATE 4

A Hardy St George multiplier with ribbed foot and largely in original condition.

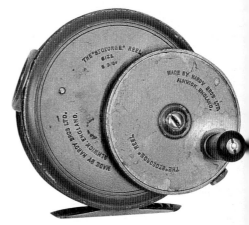

(below) An Allcock salesman's wallet showing the company's gut-eyed flies.

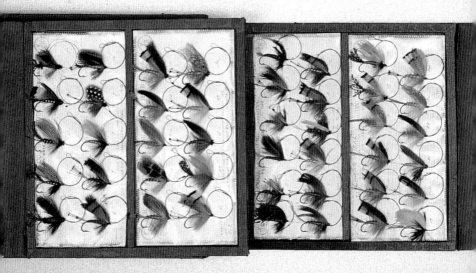

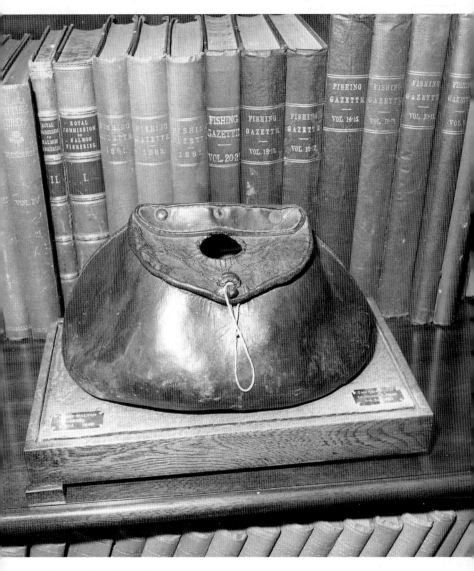

Legend has it that this leather creel – a fine example of seventeenth century work – was once owned by Izaak Walton. It is now owned by the Fly Fishers Club.

PLATE 5

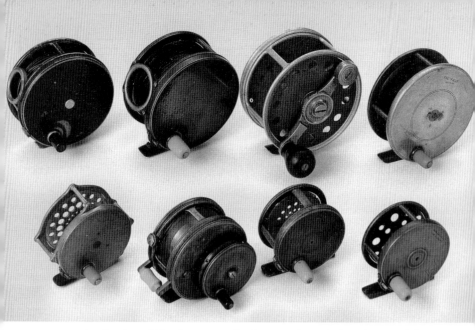

A selection of Hardy trout and salmon reels including *(top row left)* a rare 3⅞ in. Taupo Perfect; a 3 in. Bougle *(bottom row left)*; a 4¼ in. Fortuna *(top row third from left)* and a 2½ in. brass-faced Perfect *(bottom row third from left)*.

PLATE 6

(left to right) A rare Hardy 'Carry All' wicker trout creel from about 1895 with large brass clasp stamped with the maker's name; a German fruitwood line winder from about 1910 with six adjustable arms on a rectangular base; a very rare kidney-shaped painted tin creel made about 1870.

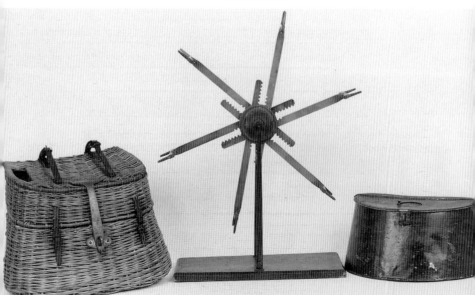

in the vast majority of cases, would not have dreamed of adding their names to their reels.

Already by 1908 Hardy Bros were exporting reels all over the British Empire and they were conscious of their reputation, as this extract from Hardy's catalogue of 1908 reveals:

The Perfect reel has gained a world wide reputation as the very best fly reel ever invented, either for trout or salmon fishing. Its simplicity and great strength of construction are at once apparent – the ease with which it can be regulated to give any reasonable brake pressure. The fact that its brake pressure is adjustable only as to drawing out line so that it does not interfere with the normal pressure used while winding in marks it as the only reel in which alteration of the brake action is wisely applied.

The salmon sizes, 3¾ in. to 5 in. inclusive – have all been further improved by the addition of a patent revolving line guard, while an improved system of check work of a new and very strong character has been applied. Referring to the former, all anglers are aware of the trouble caused by the line getting behind the reel – particularly if shooting line. Many lineguards, both metal and leather, have been designed to obviate this, but the employment of this ring renders any form of guard quite unnecessary as the line does not find its way around the back.

Hardy's were jealous of their innovatory work, but inevitably such was the prominence of their position in the tackle making world other manufacturers tried to copy what they were doing. This applied, for example, to the Hardy regulating check mechanism and the following extract, again from a catalogue of 1908, hints at a dispute not unlike that two centuries earlier between the great hookmaker Kirby and his rivals:

We wish it to be distinctly understood that this reel [the Perfect] is totally different in principle and construction from any other so-called regulating check reel. We mention this as there are one or two so-called regulating check reels which have a screw or other device that create a resistance between the revolving plates in order to retard the action and which makes the reel equally stiff whether winding in or paying out the line. The best one can say of such an arrangement is that it is very crude indeed for the reason that it is not desirable to increase the friction in winding up. In fact the resistance in this direction should be as light as possible and arranged so as not to be alterable. The portion of the check which it is necessary to alter is that which is brought into operation by the drawing out of the line and it is in this respect only that the Perfect reel can be altered. The value of this arrangement over any other existing plan is very apparent.

In a catalogue of 1892 there is, tucked away in tiny print at the bottom of a page that describes the Perfect reel, the following curious reference to aluminium.

It is the opinion of Messrs Hardy, formed from experiment that this metal [aluminium] in its present state is too soft for reels. The bearings wear out directly.

Clearly the brothers had made reels with the lightweight metal and found it wanting. But by 1897 a solution had been found, as the catalogue for that year proudly announces:

The metal called alumin of which most of our best reels are now partly made, is an alloy consisting of a proportion of other substances with aluminium to impart to the latter metal rigidity and strength. The combination of qualities thus produced is absolutely unique; as no other metal suitable for reels has yet been introduced, which combines hard-wearing qualities with strength. To put

the matter plainly, alumin taken bulk for bulk is equal in strength to the best wrought iron and only one-third in weight.

But if Hardy's is the great name in fly fishing reels there can be no doubt about the greatest name in coarse fishing reels: Allcock. And much as Hardy's greatest fame rests with the Perfect reel so much of Allcock's fame lies with its manufacture of just one model: the Aerial. The Aerial is, with the possible exception of the Illingworth early fixed spool reel, the most sought after of all coarse fishing reels.

The original Allcock was a needle manufacturer in Redditch, Worcestershire, but by the middle decades of the nineteenth century the founder's son, Samuel Allcock had transformed the business into a thriving tackle making concern. The company made rods, reels, lines and many other items of tackle.

The earliest Aerial reel, introduced in 1896, came about as a result of the rage for the bicycle, which in the closing years of the Victorian period had reached heights of popularity which have not been matched since. The idea of thin spokes running between a hub and a rim gave bicycle wheels new strength and incredible lightness and the same technique produced a free running ultra-light reel that would spin like a top at the least encouragement and, with its skeletal frame, would ensure that line dried very quickly indeed.

Early examples of this most collectable reel have wooden backs (generally referred to as Coxon Aerials after the inventor) and they were made in the following sizes: 3, 3½, 4 and 4½ in., and though the details of styling and construction varied over the years Aerials were produced continuously until 1966. A reel described as a New Match Aerial was then produced between 1965 and 1971 but it never regained the popularity of the earlier models and though a perfectly useable and attractive reel, it is probably the least collectable of all Aerials. Allcock reels ceased to

be made a few years after the company was taken over by the American tackle manufacturer Shakespeare.

Aerials were made in a range of sizes and styles – some models were unventilated – but the company also made a range of excellent fly reels, wooden Nottinghams and big sea reels. Allcock reels can be identified by their stag logo.

The London firm Farlow's who started life in 1840 and are still going strong, made a range of reels and other items of tackle. In the early days they made wooden reels, brass winches, both multiplying and plain, sea reels and multipliers. Among the Farlow's rarities are the Billiken multiplier (made between 1911 and 1940) and the company's baitcasting reel, which in appearance is much like a Malloch sidecaster. It was made in the early 1920s. Farlow's sold a number of different fly fishing reels and they even sold a ventilated Aerial under their own name.

Brass winches and brass and alloy fly reels in a whole host of sizes were also made by dozens of less well known firms – firms like Haywood, Foster and Milward among many others – and of course there are the thousands of lovely anonymous, unmarked and unsigned reels which turn up. Because of their lower price, these latter reels can form the nucleus of a splendid collection of early tackle.

Reels from the 1950s and early 1960s are also likely to become increasingly collectable – and valuable – as time goes on. Reels made at this time represent the last era of tackle-making using relatively conventional metals – before the coming of space age materials. At the moment many of them, particularly by makers such as Grice and Young (who made the splendid Avon Royal Supreme centrepin reel) can still be had for just a few pounds. Already the patina of time has descended on the early models of this reel and what is thrown or given away today may soon become highly collectable, even a rarity.

America's most significant contribution to angling and tackle manufacture is undoubtedly the reel, and more

specifically the multiplying reel. The Americans did not invent the multiplyer, but they certainly brought its design and manufacture as close to perfection as it is ever likely to get. That said, the Americans were also responsible for some of the finest rods, fly reels, and accessories, particularly plugs and spinners.

The great early reel makers in the USA date back to the first and second quarters of the nineteenth century. Before that it is likely that much of the better made tackle used in America was actually made in Britain. It was the gunmakers and watchmakers, particularly in Kentucky, who led the way when it came to the greatest developments in the manufacture of multipliers.

The watchmaker George Snyder, at work in Kentucky in the early years of the last century, turned the simple winches and multipliers then available as imports from Europe into a far more sophisticated angling weapon. Little is known about Snyder but on the rare occasions when his beautifully made reels come on to the market they command very high prices. The development and enthusiasm for the multiplier in America was to some extent determined by the species sought by American anglers. These species, particularly the tarpon which became a hugely popular sporting quarry towards the end of the nineteenth century, tended to be bigger and more hard fighting than the majority of freshwater fish caught in British waters. A powerful, reliable and precision made reel was therefore essential.

American multipliers are generally referred to as bait casting reels and among the great early names, based either in Kentucky or in the other great centre of production, New York, are Snyder, Meek and Milam (originally jewellers and watchmakers), J.C. Conroy, Andrew Clark, Bates & Co, Bailey, J.B. Crook & Co and the two brothers Julius and Edward vom Hofe. Early multipliers occasionally achieved very high gear ratios – as much as 9:1. They were made in nickel silver and brass and compared to early British

multiplying winches they were remarkably smooth-running and could cast great distances.

The Americans also came up with some highly inventive fly reels including the first automatic re-winder – the Automatic Fly Reel by Loomis, which began production in the 1880s.

But perhaps the best known maker of American fly reels was Charles Orvis who, in the 1870s, founded the business that bears his name to this day. The earliest Orvis fly reel had a heavily perforated side plate, narrow drum and a crank handle and it came in a distinctive wooden box.

Other long-lived American companies who made fine tackle are Shakespeare (founded in the 1890s) and Pflueger (founded in the 1860s).

3

'He makes a May-flie to a Miracle and
furnishes the whole country with angle-rods.'
Addison, *The Spectator*, 1711

RODS

So far as we can tell – although it has to be admitted that there is little evidence to support the contention – the very earliest rods used in England were simply long, one piece affairs cut from the nearest ash or hazel wood or hedgerow. There seems little doubt that, in the late medieval period, very few people travelled any distance specifically to fish and so jointed rods were not really necessary, but, equally, there can be little doubt that from the middle ages on men enjoyed fishing as a pastime rather than solely as a means to supplement a subsistence living.

By 1496 when the *Treatyse of Fyshing with an Angle* – angle here means hook – was published, anglers were using jointed rods of some sophistication. Dame Juliana describes a rod made in three sections with a butt piece made from the wood of the blackthorn, the crab apple tree, the medlar pear or the juniper – all woods noted for lightness and strength. For the middle section our fifteenth-century ancestors would have used a more flexible timber – hazel, willow or ash – and for the top a fine piece of strong flexible hazel, whalebone or even tortoiseshell. Dame Juliana's rod was 18 ft long and to prevent these long early timber rods from swelling up when wet (and thus becoming virtually unwieldable), elaborate recipes for paint and varnish were invented and applied.

More than two centuries after Dame Juliana's book appeared, Izaak Walton recommended a dyed linseed oil, while other anglers and rod makers used india rubber boiled with linseed oil or spirit lacquer mixed with gum. The idea was that the paint or varnish should protect the rod from the wet, but also flex with the rod without cracking. Numerous curious dyes were used to colour the rod according to the taste of the angler: for a mottled rod Daniel, writing in his *Rural Sports* of 1807, recommends 'Copperas' applied with linen; for red he recommends Dragon's blood mixed with gum sandrich, spirit lacquer and 'an ounce of Gamboge'; for a cinnamon colour he suggests applying aqua fortis with a feather.

Great care was taken, too, when it came to choosing and seasoning wood intended for rod making – suitable poles were left for two, possibly three years, and for the whole of the seasoning period they were tightly bound to thick, straight pieces of timber or boards in order to keep them as straight as possible; certain sections, if used for a particular part of the rod, might be heat treated to add strength; rods might even be covered with thin, painted leather or with oil-painted parchment.

The elaborate and time-consuming work which went into early rod-making where it was done at home, was no doubt largely the preserve of a relatively small number of wealthy anglers – most people still simply cut a hazel rod from a hedgerow – but the realisation that care and attention to detail could produce a rod that was a real pleasure to fish with provided an open invitation to tackle manufacturers who knew that what they had the time to make others would certainly have the money to pay for.

There is some evidence (most notably in Dame Juliana's book) that early rods may have been jointed simply by hollowing out the ends of the sections, but by the late seventeenth and early eighteenth centuries many rods would have been made spliced – i.e., in sections whose ends tapered in such a way that they could be lashed together.

Indeed right up until the 1960s many anglers still preferred the through action produced by rods with spliced sections. The splice permitted the sections of the rod to, as it were gradually join each other rather than butt together as is the case with ferrules. Purists argued (and some do to this day) that this produced an incomparably good action.

It is certainly a mistake to believe that early rods – say from the mid 1600s until the end of the nineteenth century, were always cumbersome great unwieldy things. The reason such care was taken over their manufacture was precisely because with great skill and care a rod could be produced with an action neither too stiff nor too floppy and also light enough to use all day.

It is true that these rods were heavier than the carbon and boron rods of today and they were more unreliable and lasted a shorter time (unless carefully looked after) but the best of them reveal the ingenuity and skill of the early rod makers. When one examines surviving examples of their work, one cannot fail to be impressed by how brilliantly they achieved their desired aims without the benefit of materials we take for granted today.

The importance our ancestors attached to action and quality may be judged by Colonel Venables, who, writing in 1662 (in *The Experienced Angler or Angler Improved*), said that 'if your rod be not most exactly proportionable as well as slender it will neither cast well, strike readily or ply and bend equally, which will very much endanger your line.'

And writing in 1833, Thomas Salter reveals how precise our ancestors were in choosing rods made from particular materials for particular tasks and species of fish. Indeed Salter's account of rods is so interesting it is worth quoting at length:

As the angle-rod is a material article in the angler's catalogue, great care should be taken to procure a good one. The fishing tackle shops keep a great variety, made of bamboo, cane, hazel, hickory &c and of different lengths;

some fitted as walking canes and others to pack in canvas bags; the latter are to be preferred because you may have them of any length, and they are made more true and stronger; the rods made to pass for walking canes seldom exceed twelve feet, which is, generally speaking, too short; those made of bamboo cane are best for general fishing, having several tops of various strengths, but the rods made of the white cane are much superior for fine fishing, particularly for roach, being very light in weight, yet stiff. In choosing a rod observe that it is perfectly straight when all the joints are put together, and that it gradually tapers from the butt to the top and is eighteen feet long; if longer they seldom play true.

Some strong and fit for trolling, other for barbel, perch &c. Rods fitted with several tops, all packing together, are certainly very convenient when taken on a distant journey; but the angler who wishes to have rods neat and to be depended on, must keep one for trolling, another for barbel, perch or other heavy fish and also a fine light cane rod for roach and small fish as well as those for fly-fishing.

Cane rods were certainly available in the mid seventeenth century, but these were whole cane, not the split bamboo rods we know today. Three-section built cane rods were, however, available in some form by the end of the eighteenth century if not earlier and by the mid nineteenth century three section cane rods were being made by a number of makers, among others Ustonson, the great London reel maker.

Eighteenth and nineteenth century rods were usually fitted with brass rings that folded flat when the rod was not in use and they often came with several tops in order that they could be used for a range of different tasks – fly fishing, bottom fishing, trolling or whatever.

Valise or multi-section travelling rods are a feature of early rod making. These rods were often beautifully made

with ivory ferrule-stops and spare tops; where they have survived they are if anything more collectable than more conventional two and three piece rods.

Thomas Salter has some interesting comments on how a rod should be fitted with rings and reel:

There is some difference of opinion about the number of rings necessary for trolling rods; those who have their line on a thumb winder, or on a bank runner seldom place more than two or three rings on their rod and others have only a large ring at the top; but if a winch is used, there should be a ring to every joint, except the butt; that is, fasten the winch to the butt, about a foot from the bottom, and let that joint be without a ring, and all the other joints, except the top, to have a ring, each made of double brass wire, fixed so as always to stand out, and nearly large enough to admit the top of your little finger; the top joint should have two rings, the top one nearly three times the size of the other. This prevents any obstruction to the line running, which is of material consequence. I have two tops to my trolling rod, which I always carry with me in case of breaking one &c: one is made very flexible, with wood, and a whalebone tip, about two feet long; to this, for strength and security, I have a ring on the wood part as well as the large one at the whalebone tip.

Those anglers who may object to have such large rings because they prevent the several joints packing one within the other can have such rings, if they prefer them to those which lay close, fixed to metal ferrules, made to fit each joint of the rod, which they may carry in their pocket and put them on or off at the commencement ... Some anglers use a few small brass curtain rings sewed to loops of leather and pass the loop over each joint of a stout walking cane rod; these leather loops are made in a similar manner to those which you may see in the fishing tackle shops, passed over, as the means of keeping

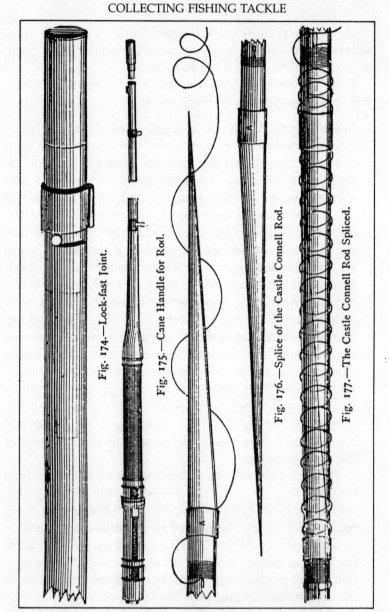

Fig. 174.—Lock-fast Joint.

Fig. 175.—Cane Handle for Rod.

Fig. 176.—Splice of the Castle Connell Rod.

Fig. 177.—The Castle Connell Rod Spliced.

By the end of the nineteenth century anglers could still choose the ancient, splicing method of joining a rod's sections together or they could opt for one of the more modern methods, as this illustration reveals.

together the several joints of hazel and other common fishing rods.

Numerous ideas were tried to reduce the damaging effects of water penetration and to increase and preserve the strength and flexibility of early rods: one or two companies tried wrapping their rods in a web of fine wire, others arranged things so that the lower sections of the rod fitted into the upper sections – water that ran down the rod would thus be prevented from entering the joint.

Early built cane rods (rather than rods which were made with split cane tops only – these appeared on the scene at least fifty years before built cane rods) suffered problems with the glues used to hold them together. But with the improvement in glues and after experiments with five and six strips of cane glued together with top quality isinglass, it was accepted that six strip cane produced the very best rods and some of the finest of these early cane rods were undoubtedly those produced by Charles Murphy and a little later by Leonard, both in America.

Wealthy fishermen who commissioned rods often asked that they be engraved or decorated in some way – butts might be silver or silver plate, they might be inlaid with rare timbers and ivory while the metal parts of the rod might have engraving; stoppers for the hollow ends of each section might be made in carved wood or ivory.

In the 1840s Farlow's, the London tackle manufacturers, sold a wide range of rods and the price variation between the different types and styles is revealing: a two joint hazel rod with tin ferrules designed for bottom fishing could be had for 5d (2½p); the same rod with an additional whalebone tip (whalebone was strong, springy and light) cost one shilling (5p); a cane rod with three sections cost 10 shillings (50p).

Hollow bamboo cane was used right through the nineteenth and early twentieth centuries for long roach poles and many examples still survive. It is extremely rare for

rods of this kind to be marked with a maker's name, but they are often well made and may still be had relatively cheaply.

It is very difficult to establish precisely when fly fishing rods – in the sense in which we use the term – were first made. Early nineteenth century commentators and writers refer to whipping rods which seem to have been used with tapered lines and artificial flies.

Thomas Salter, an excellent guide to fishing practice during the early years of the nineteenth century, includes a detailed and fascinating description of early 'whipping':

In respect of fly rods, I believe the London tackle makers can furnish as good as any that are made for sale; though I know some gentlemen are partial to those manufactured in the North and West parts of England. I have purchased rods at Exeter in compliance to the request of some friends who reside in those parts but I never experienced any advantage in using them over what I carried with me from the metropolis.

Fly rods are made of bamboo, cane hickory hazel &c from fifteen to eighteen feet long; the common hazel rod may be used by the young angler, during his noviciate, to practice throwing a fly on land in a field or any other convenient place, which practice I should recommend before he casts his bait on the water.

In casting or throwing a fly while yet a novice, observe the following rules – having fixed the winch on the butt of your rod, draw the line through all the rings of the rod to the top and then again as much more as will reach within a yard of your butt end; the line will then, of course, be nearly as long as the rod which will be quite as much as is necessary for a learner to throw; indeed when you have learned the art of throwing a fly thirty yards, to any given spot, you may use line *ad libitum*. Having fastened your bottom [cast] to the line hold the hook by the bend in the left hand, between your thumb and finger; the rod in the

right hand pointing to the left; bring the top of the rod gently round to the right, making a sweep over your right shoulder, casting forward the fly which you let go the moment you are in the act of throwing; practise this with a moderate wind at your back till you have gained the art. Some prefer the following method of casting – raise your arm and forming a circle nearly round your head from the left shoulder, by waving the rod cast the line from you before you return your arm from the head; then draw the fly lightly and gently towards the shore.

By the middle years of the nineteenth century rods, reels and just about every other item of tackle in common use were being made all over Britain. London still held sway when it came to the top end of the market, but companies in Birmingham, York, Edinburgh and Aberdeen made tackle of the highest quality and, as the century progressed, the general mania for new inventions which took hold in almost every manufacturing process had its inevitable effect on the fishing tackle makers: new ways of securing the sections of the rod were invented, machines for shaving gut into the finest lengths appeared and timbers from which rods were made grew ever more exotic – washaba and blue mahoe from British Guiana and Jamaica and steel-wood from Cuba.

Like their reels, Hardy rods were in the main numbered and the ingenious Hardy brothers, not content with the innovations of their reel making added clever extras to their rods – like steel centres to increase strength and resilience. They also patented the Lockfast joint in 1892 and in 1890 introduced the bridge ring which gradually replaced the snake ring. The company continued to make greenheart and hickory rods well into this century (such is the eternally conservative nature of the angler!) and they made coarse and sea fishing rods and rods designed specifically for fishing abroad.

Among the best known Hardy cane rods are the

47

Perfection (manufactured from 1885), the Cholmondeley Pennel (manufactured from 1885 and built to the design of, and named after, a famous Victorian angler), the Houghton Dry Fly (from 1894) and the Gold Medal which, extraordinarily, was made from 1885 until as late as 1965.

Hardy's probably invested as much time, money and effort in the development of their rods as they invested in their reels. So much so that by 1892 they claimed they were the largest manufacturer of cane rods in Europe. And, as an 1892 catalogue reveals, they had their own explanation for their phenomenal success:

> We are frequently asked – how is it that Hardy's rods are so much better than others? The reason is very simple. In the first place $15/16$ths of all the rods offered are either factory made or imported and there is not that careful detail given to construction which is so necessary, the goods being made to price without attention to quality. It has been no small task to bring their work to the perfection they have and the difficulty of finding suitable canes is very great. Bamboos may be had in almost any quantity, but they have after trying almost every district and many samples sent them by the Indian Forestry Department, found that there is one particular district which produces canes of a quality superior to all others.
>
> This cane they now use exclusively and have appointed agents on the spot who buy up all the choicest and have them seasoned under their instructions – not burned until the fibre is destroyed as is usually the case, but properly oiled, fired and seasoned in a special manner. This renders them exceedingly tough and springy. They are then shipped and picked over in their works, only the very choicest being retained for their own trade. The remainder being disposed of to cane merchants.

But if Hardy's went to such trouble in selecting their cane, they were equally precise and demanding when it came to turning the cane into rods.

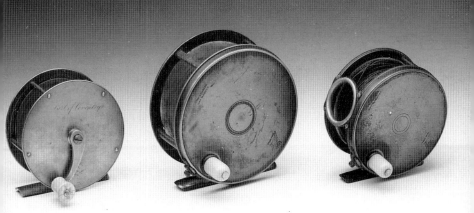

(left to right) A Jones of London brass crank-handled salmon reel inscribed 'Earl of Coventry'; a 4½ in. brass-faced Perfect salmon fly reel with Straightline and Rod In Hand logos; a 4 in. brass-faced Perfect, also with Straightline and Rod In Hand logos.

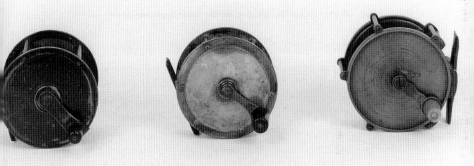

(left to right) A brass 4 in., wide-drummed winch by T.P. Luscombe & Co. made in about 1880; a rare Hardy brass crank 4 in. salmon-fly reel from about 1885 and a 4 in. brass, loch-trolling winch also from about 1885.

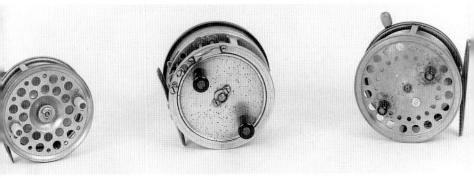

(left to right) Percy Wadham's The Cowes 4 in. alloy combination reel made in about 1928; a 4½ in. Dorado reel from *c*1930 and a Hardy Super Silex 4½ in. extra wide alloy baitcasting reel, also from about 1930.

PLATE 7

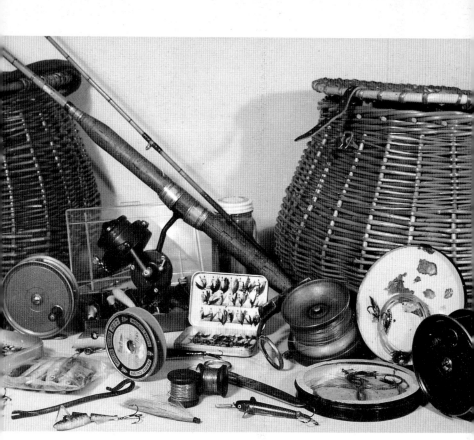

A glorious collection of early tackle including a Malloch sidecaster, gut-eyed salmon flies, Wheatley fly box, disgorger, an early cast damper and pot-bellied wicker creels.

PLATE 8

(left to right) An early line twister, a beautifully marked wooden fish decoy and a fly reel decorated with engraved flies.

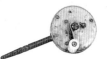

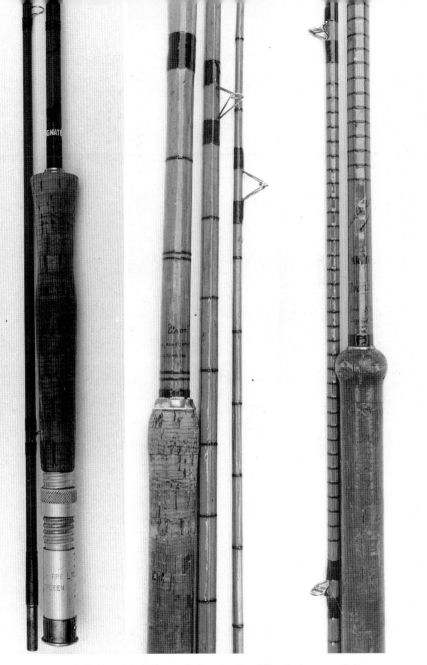

Classic rods *(left to right)*: Sharpe's Scottie; the Allcock Avon and the
Richard Walker Mark IV Avon built by B. James.

PLATE 9

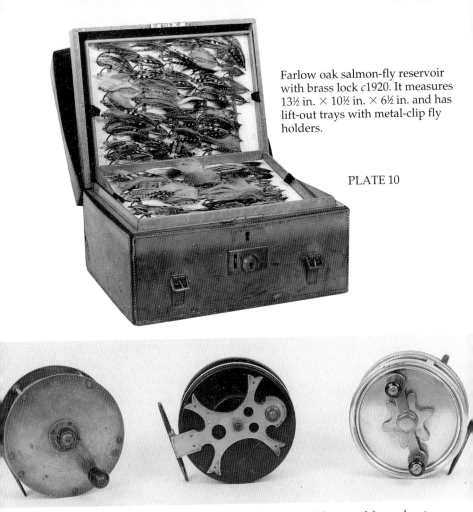

Farlow oak salmon-fly reservoir with brass lock *c*1920. It measures 13½ in. × 10½ in. × 6½ in. and has lift-out trays with metal-clip fly holders.

PLATE 10

(above, left to right) Anonymous 6 in. brass sea fishing reel from about 1910; rare Milward 'frog back' reel; Hardy Fortuny 6 in. duralumin big game reel from the 1930s.

(below, left to right) Hardy brass-faced Perfect 4½ in. salmon-fly reel; a very rare Hardy 4½ in. all-brass Perfect salmon reel with its original bronze finish, made about 1891; Hardy brass-faced Perfect 4¾ in. salmon-fly reel from 1908.

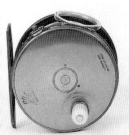
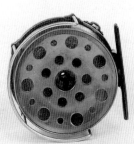
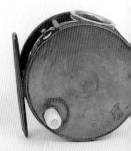

The method of their handling, the built-up, split-end joints, the metal lining and sealing of every part; the perfect shape and jointing of the sections, together with the true and even distribution of power and substance, render these rods so superior to all others in point of quality and merit that they stand alone.

The Palakona was the rod of which Hardy's were most proud and the company's advertising included extraordinary illustrations of the rod coiled up to show just how indestructible it really was.

By 1928 all Hardy rods were offered in natural bamboo colour or in what was described as an inconspicuous, dull French grey. They were also available in six strip single built, double built (two lots of six strip on top of each other), double built with steel centre, octagonal (eight strip) and even nonagonal (nine strip). Double building involved using only the very hard outer edge of the sections of whole cane and making up the required depth by having two layers.

Hardy's efforts to distinguish between the quality of their rods and those of other manufacturers were important simply because anglers always mistrusted new-fangled materials until they were well proved and Hardy's knew that adverse publicity for cheaper, poorly made cane rods, could have a damaging effect on sales of their own carefully made models.

The sort of problems that were encountered early on are perfectly illustrated in a letter that appeared in *The Field* magazine in August 1885.

Sir, I should be very glad if some of your readers will give me their experiences of the new fashioned split cane rods that everyone now seems to talk about, and I sincerely hope they are not as disastrous as my first experience of these rods has been. I lately, after an absence of three years, returned to my old haunts on the Conway, which, I may add, still keeps up its old reputation of

being the worst salmon river in the United Kingdom. I was fishing a favourite pool, perhaps known to many of your readers as Tyn-y-Cae, when I struck into a good fish with one of these rods, which a friend had kindly lent me – a beautiful rod to fish with, got up regardless of expense, but, as the result will show, not to be depended on. The first run the fish took – bang went the rod, snapping like a carrot below the first ferrule. Fortunately a friend was looking on who, at my bidding, seized the two remaining joints, which were gradually disappearing into space, or rather water; he held them up while I stuck to the butt and we eventually brought the fish, thanks to his being well hooked, to the gaff, when he scaled 12 lb. It is needless to say I fished no more with this 16 ft of split cane ornamented with silver plate.

The letter writer, who signs himself Pilot, gave the name of the rod maker, but the then editors of *The Field* thought discretion the better part of valour (no doubt with an eye on the libel laws) and removed it. All we know is that the rod had been made in America, but this was the sort of thing that kept anglers using greenheart in spite of the best efforts of makers like Hardy's who produced top-quality cane rods.

The company's efforts to emphasise the reliability of their rods can seem almost desperate at times, as another early catalogue entry reveals:

Special Note re cane built rods – there are several firms advertising 'English' made cane built rods (it having been proved that they are so much better than the American) and arrogating to themselves the credit for English rods being best. It should be remembered that it is Hardy's rods that have proved to be the best and won the gold medal in 1883. As has been pointed out there are firms who are buying cheap American rods and offering them as English make, guaranteed to stand two years etc and we caution unwary buyers against them. In support of this we can offer for sale American built rods for 15/-

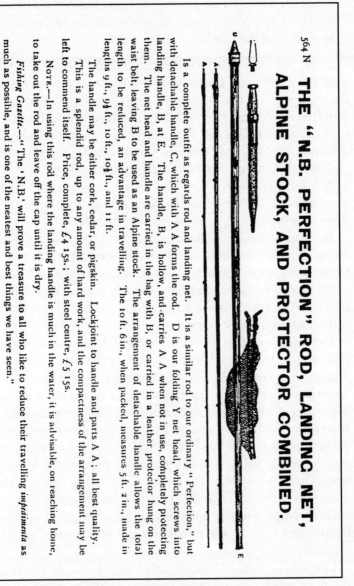

564 N THE "N.B. PERFECTION" ROD, LANDING NET, ALPINE STOCK, AND PROTECTOR COMBINED.

Is a complete outfit as regards rod and landing net. It is a similar rod to our ordinary "Perfection," but with detachable handle, C, which with A A forms the rod. D is our folding Y net head, which screws into landing handle, B, at E. The handle, B, is hollow, and carries A A when not in use, completely protecting them. The net head and handle are carried in the bag with B, or carried in a leather protector hung on the waist belt, leaving B to be used as an Alpine stock. The arrangement of detachable handle allows the total length to be reduced, an advantage in travelling. The 10 ft. 6 in., when packed, measures 5 ft. 2 in., made in lengths 9 ft., 9½ ft., 10 ft., 10½ ft., and 11 ft.

The handle may be either cork, cedar, or pigskin. Lockjoint to handle and parts A A; all best quality. This is a splendid rod, up to any amount of hard work, and the compactness of the arrangement may be left to commend itself. Price, complete, £4 15s.; with steel centre, £5 15s.

NOTE.—In using this rod where the landing handle is much in the water, it is advisable, on reaching home, to take out the rod and leave off the cap until it is dry.

Fishing Gazette.—"The 'N.B.' will prove a treasure to all who like to reduce their travelling *impedimenta* as much as possible, and is one of the neatest and best things we have seen."

Hardy rod and net combination advertised in 1897.

[75p] each at a profit. Remember that Hardy's is the only make of any value and the name of Hardy Brothers is security for the quality.

Among the cane oddities built by Hardy's over the years was the Poole combination rod and handle-less, friction driven reel. This was a three piece Palakona rod with a 3 in. handle-less Bougle reel which screwed to the bottom of the butt of the rod. The rod was designed and built at the suggestion of a Mr Poole who declared that having the reel at the end of the butt improved the balance. The design did not, however, meet with widespread approval. Hardy's also made a combination Perfection rod and landing net offered with either a cork or pigskin handle.

Rods very rarely sell for high prices largely because early models in hickory, lancewood, hazel, greenheart or ash are these days considered too heavy and unreliable to use – early Hardy reels, by contrast, are very often bought by collectors who fully intend to use them as well, perhaps, as intending to display them.

Exceptions to this are cased cane rods, or prototypes, or rods made by special commission perhaps for a famous angler (rods owned by Ernest Hemingway and Clark Gable have been sold for very high prices in recent years for example). Cane rods are considered far more collectable than other early rods, except in a few instances, because an early Hardy or Leonard cane rod is likely to be an eminently usable thing if it has survived in reasonable condition. The same applies to cane rods by many other makers from the early years of this century. So long as these cane rods are hung and not left leaning (which quickly imparts a permanent kink to the cane) and generally cared for they are both collectable and usable.

Greenheart – one of a number of woods imported during the nineteenth century from British Guiana and other countries the British had colonised – was probably the most popular timber for rods during the second half of the

nineteenth century and many anglers insisted for years that the new-fangled cane simply could not compete.

A glance at the range of rods sold by Hardy's or Farlow's early this century will reveal that cane only gradually replaced greenheart, much as, today, carbon and boron have only gradually superseded fibreglass. Such was the quality of cane that many anglers even today still believe that there is no better rod-making material and if anything there has been a recent resurgence of interest in cane. Hardy's among others still make a cane model.

The practice of including spare tops (occasionally one rod might contain a spare top to make it suitable for spinning and another for bottom fishing) continued until very recently, only really ceasing with the introduction of carbon fibre and the discovery by manufacturers that anglers were more than happy to buy two, three or more rods for different tasks.

Sea fishing rods in cane are common and easily obtained largely because as with reels, sea angling is very much the poor relation and has probably had least attention from collectors. Cane sea rods tend to be short and extremely powerful, but they are often well made. Sea angling has a much shorter history than the other branches of the sport and it is likely that few bothered to fish the sea with rod and line until well into the nineteenth century.

It is unlikely therefore that much tackle was made before this period specifically for sea fishing. However Salter, writing in 1833, does describe his own enthusiasm for sea angling as well as the tackle and techniques he adopts: 'I always use a strong, platted silk line of a dark colour and upwards of seventy yards long, wound on the largest size multiplying winch, which I fasten on a very stout bamboo trolling rod, twenty feet long.' Salter's shot and float matched the might of his main tackle.

An edition of the *Fishing Gazette* published in 1896 does suggest, however, that things had changed greatly in the 60 odd years since Salter published his comments on sea

fishing: 'Sea fishing is undoubtedly coming rapidly into fashion,' writes one of the magazine's correspondents. 'Almost every exhibitor [at the Fisheries Exhibition at Westminster] makes a feature of tackle and rods for sea fishing and Mr Murton shows a well-made 15s [75p] combination sea rod and one of greenheart at 7s 6d [37½p].'

Greenheart salmon rods of the mid to late nineteenth century can be anything up to 25 ft long and although greenheart tops were prone to exploding (almost literally) with a great crack and a cloud of dust and quite unpredictably, where these rods survive they are often marvellous examples of the rod maker's art and therefore of course well worth adding to a collection. Greenheart was popular because apart from its strength it had a lovely soft through action.

The American tradition of rod making may be shorter than that in Britain but it is almost as illustrious. Built cane rods were not first made in America, as is sometimes claimed, but our American cousins are generally credited with having made the first really fine examples. Among the great American makers are H.L. Leonard, Charles Orvis and Charles Murphy. Early makers produced fine three- and four-strip cane rods – makers like Samuel Phillippe (at work during the 1840s) of Easton, Pennsylvania – but it is generally recognised that six strip manufacture produced the truly great early rods and Leonard probably takes pride of place among early six-strip makers.

Leonard also introduced a special brass plate which fitted into the bottom of the ferrule to prevent the end of the cane being affected by damp penetration. He also experimented with eight and 12 strip rods.

Such was the fame of Leonard and others that inferior manufacturers tried to pass their rods off as genuine Leonards, but this had the benefit (for later collectors) of forcing the company to stamp the butt cap or reel seat with the company name and we are now able to recognise their

work at a glance. Other common identification marks on rods are the Indian ink signatures written on the rod just above the handle and varnished over. The difficulty here is that as rods were refurbished over the years these identification marks have been obliterated. But as with early brass reels, quality often shows in the lack of deterioration of an item and a good rod may well have survived in excellent condition. Such a rod, even if it now appears to be anonymous, would be worthy of the attentions of the collector.

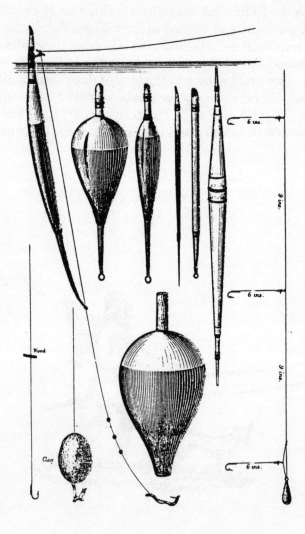

A selection of late nineteenth-century floats.

4

'Use a middle-siz'd flie-hook ... the flie line
should be made very taper.'
Richard Howlett, *The Angler's Sure Guide*, 1706

FLOATS, FLIES AND OTHER ACCESSORIES

The fishing tackle collector who turns his attention to the rich variety of floats, flies and other accessories essential to the sport is likely to be richly rewarded. Indeed accessories – everything from maggot tins and fish kettles to bank runners, creels, nets, gaffs, balances and fly-boxes – have not really received the attention they deserve. This is largely because accessories have always tended to be seen as somewhat ephemeral compared to rods and reels. At the very least, the great advantage accessories have over rods is that they are often small enough to display effectively.

The number of very early accessories – say from the seventeenth century – is only ever likely to be small, however many attics we search, but every year fascinating items do appear, particularly those made in metal and wood. More fragile items such as leather and silk artificial minnows may have vanished forever, but the records of the early makers reveal that a vast range of items was once made. Ustonson list the following among their stock in about 1770:

All sorts of pocket books for tackle; mennow kettles; nets to preserve livebait, fishing panniers and bags; variety of gentle boxes and worm bags; landing nets and hooks

57

[gaffs]; fishing stools; wicker and leather bottles and many other curiosities in the way of angling.

Other companies offered fine turned corks, artificial flies and mice, line-twisting engines, tin bait boxes, cork trimmers, clearing rings and cane floats. By the mid-nineteenth century the range of tackle accessories had expanded to include wood, plywood or wicker creels in a range of styles and sizes, ivory and wood cast winders, landing nets and keepnets, priests and, from the United States, fish decoys.

For the game fisher the most collectable early items are likely to be flies and fly boxes. Flies inevitably have not survived in great numbers largely because wear and tear and the effects of moths and other creatures have destroyed a great many early examples.

However, magnificent fly boxes and fly chests, particularly from the early years of this century, do turn up now and then, complete with their contents and these fetch high prices. The storage of flies became, for the Victorians, a matter of great importance – witness Hardy's Unique Salmon Fly Cabinet in mahogany with a solid leather case described in detail in the company's 1908 catalogue:

A very handsome and convenient mahogany cabinet, 9½in. high, 9¾ in. wide by 6¾ in. deep, fitted with ten salmon fly trays with clips to hold 266 flies. The trays are fitted in front with washable tablets to write the names of the flies on. There is a space at the bottom with a perforated lid to hold aldo carbon to keep away moths. The cabinet is made with a lid to lock in front of trays keeping all secure. Sunk brass handle and name plate.

Rather than having trays which rested one on top of the other (common among fly cabinets at the time) and necessitating the removal of all the trays if a fly were needed from the bottom tray, the Hardy Unique cabinet had drawers which slid in and out. It cost £6 6s (£6.30), a considerable sum at that time.

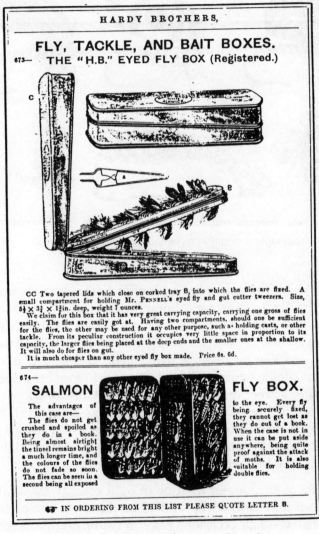

Hardy fly boxes: an illustration from the company's catalogue for 1888.

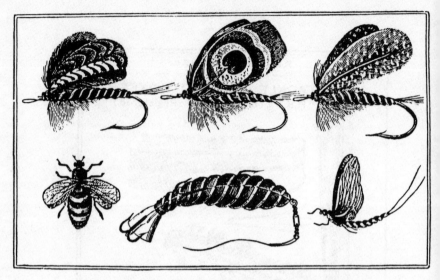

Trout and salmon flies from Salter's *Angler's Guide*, 1833.

The Victorians employed cabinet makers to turn the business of building cases for salmon flies into an art, and wonderful oak and teak boxes – or reservoirs as they were known – were often made to the most exacting standards. They were like fortresses – hand-made and jointed in the finest available hardwoods and fitted with stout brass locks and outer leather cases to make them suitable for travel.

Certainly the range of accessories was as great in the eighteenth and early nineteenth centuries as it is today. In 1750 William Wright's *Complete Fisher or the Art of Angling* suggests the following essential items for the angler:

As for your pannier let it be of light osier twigs, neatly woven and worked up and to be the more completely prepared on all occasions have in readiness divers sorts of hooks, lines, links ready twisted, hair and silk of several colours, small strong thread, lead plummets, shoemaker's wax and floats of divers sizes, line-cases, whetstone, pen-knife, worm bags, boxes, baits, scissors.

Wright goes on to describe precisely the kind of float the angler should use and how he should make it:

> Floats should be of cork for river fishing, but for ponds, meres and other standing water quill and pens will do. As for your cork let it be the finest, free from holes or flaws. Bore it through with a small, hot iron thrust in a quill sizeable, shaped with a knife to the likeness of a pyramid, egg or pear of proportionate bigness and with a pumice stone finely smooth it. The smaller end of the cork being toward the hook...

Occasionally flies by great nineteenth-century tiers – men like James Wright of Sprouston or John Allan of Ballindalloch – turn up in display frames or cases; other flies, which would now be highly collectable, were occasionally attached to the pages of fly fishing books or on display boards that were used by commercial fly tying companies at exhibitions. Travelling salesmen's wallets of flies have also survived in reasonable numbers.

Artificial flies have probably been used to catch fish for thousands of years – certainly the Roman author Aelian (170-230 AD) mentions a method of fishing that involves using hooks tied with red wool and feathers, but it is probably not until fairly late in the nineteenth century that they were cast in a way that we would recognise (although Salter in 1820 describes a kind of 'whipping' that clearly wasn't too far from the modern concept of fly-fishing). Instead artificial flies were simply dibbled on the water from the end of a long rod and on a fixed line.

The technique of throwing a long line with a fly attached, once it really took hold, certainly spawned a mass of inventive patterns and an intense rivalry between different manufacturers and individual tiers. At best the collector of such flies will be able to find examples from this period – the late nineteenth century and early twentieth.

In the early part of the nineteenth century fly tying was

still a relatively straightforward affair. Thomas Salter, who says that at that time about 100 different patterns were in use, explains his ten rules for good fly tying:

> The angler will perceive he has ten rules to observe: first, how to hold the hook and line; secondly and thirdly how to whip around the bare hook and join hook and line; fourthly how to put on the wings; fifthly how to twirl and lap on the dubbing; sixthly how to work it up towards the head; seventhly how to part the wings; eighthly how to nip off the superfluous dubbing; ninthly how to fasten; tenthly how to trim and adjust the fly for use. And note those flies whose bodies are without wings, are termed palmers; if with wings palmer flies; those whose bodies are made chiefly of wool or mohair are called dub flies; if made principally of feathers they are then named hackle flies.

Certainly early nineteenth century writers discuss some curious flies: Salter lists the following – the Pismire Fly, the Middling Brown Fly, the Foetid Light Brown Fly, the Huzzard and the Orle. Other early patterns on the other hand – the Greendrake, Stonefly and Mayfly – have hardly changed in nearly two centuries.

Examples of Victorian fly-tying equipment occasionally turn up at sales and in dealers' showrooms, but part of the problem here is that many of the great Victorian tiers disdained the use of the vice, although prickers (dubbing needles) and pincers (a kind of hackle plier) were commonly used.

Creels and baskets are a relatively unexploited area of fishing tackle collecting. Many are sold simply as 'wicker baskets' by general antique and bric-a-brac sellers who do not know why they were originally made. The traditional kidney shape (a design which helped the creel fit snugly against the waist) lasted right through from sixteenth- and seventeenth-century leather creels to Victorian and later wicker and wood creels. Wickerwork baskets were almost

Part of a series of designs for Hardy's Perfect
Creel which appeared on the market in the 1890s.

invariably made with a slot in the top through which any
fish caught could be dropped, though few anglers in more
recent times would have bothered to use a creel in this way
since they would keep their reels, fly boxes and other bits
and pieces in the main body of the creel. Small, beautifully
woven examples of wicker creels are still common and they
do not as yet command high prices, although early leather
creels are now expensive.

Among the most collectable fly boxes are those by
Wheatley, Bowness, Hardy's, Farlow's and Malloch. Early
boxes, which largely superseded leather fly wallets during
the nineteenth century, were tin and later alloy, lined with
felt or cork or with leaves of parchment between which fly
and attached gut could be placed. They came in all shapes
and sizes, square, rectangular and round, some combining
cast-holding and fly-holding areas.

In earlier centuries, anglers would have used a leather

wallet or book. These would have been made with parchment leaves (a system continued in some early fly boxes) between which the individual casts and their attached flies could be placed.

Line-making engines or twisters as they are sometimes known are fascinating and eminently collectable – they were made in their thousands until early this century when it became increasingly rare for individual anglers to make their own lines.

Twist engines, usually brass, had three hooks on a revolving plate to which three separate horse hairs or lengths of gut or silk (or a combination of these) were attached. The handle of the device was then turned until the three strands had twisted neatly together to form the line. Once a section of a twisted hair line had been made it would be knotted at either end and then attached to other similar sections until the desired length of line had been achieved. Lines could even be tapered if the line maker had sufficient skill and line making was indeed a skilled business – if care were not taken each hair in a link might not carry precisely its share of the load or the three joined hairs would not end at the same point. If they were twisted together unevenly a running fish would put strain on one or two hairs, break them and then gradually break the whole line strand by strand.

Single horsehair lines were used for gudgeon fishing (immensely popular in the nineteenth and earlier centuries) and for species up to and including roach. At the other end of the scale, the Victorian writer Francis Francis describes using 16 individual horsehairs twisted together for barbel fishing.

But on one occasion Francis hooked a barbel while fishing with a single hair – the resulting battle was recalled in his *A Book on Angling*. It is worth quoting in full if for no other reason than to indicate the skill with which our ancestors fished with what many of us today would consider woefully inadequate tackle.

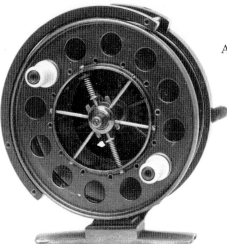

A 3½ in. Allcock Aerial.

PLATE 11

A more recent Allcock
Aeralite 3½ in. reel made
from bakelite.

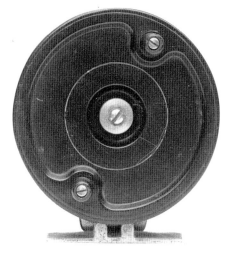

(below, left to right) A late
nineteenth-century 2½ in.
brass Jardine fly reel; a 2⅝ in.
mahogany Nottingham reel.

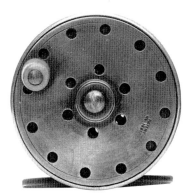

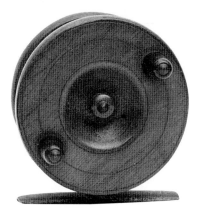

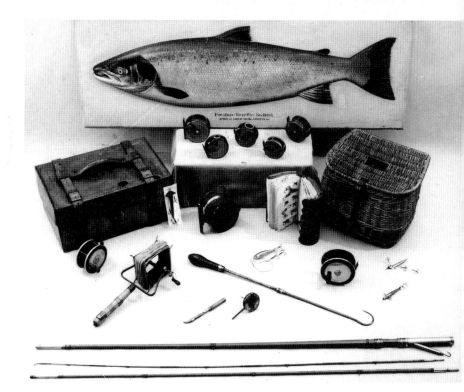

Collector's treasure trove: a carved wooden salmon, brass reels, hand held line winder, wicker creel, leather and oak fly reservoir, cast and fly wallet, an early gaff and a rod with a spring balance cleverly concealed in the butt section.

PLATE 12

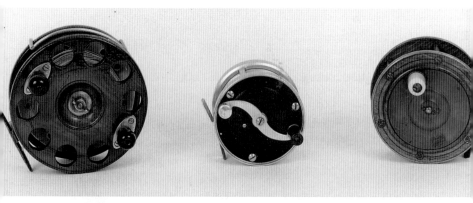

(left to right) A rare Farlow 5½ in. walnut and brass Nottingham reel from about 1900; an S.E. Bogdan 3¾ in. alloy salmon/steelhead fly reel; an Anderson Dunkeld 4½ in. rosewood and brass Perth salmon-fly reel made in about 1905.

I once remember many years since, hooking an apparently large fish on a single hair at about five o'clock one November afternoon. I played him for a long time until my arm grew tired, when I handed the rod to a friend who was with me. He tired and gave the rod to Wisdom who in turn gave it back to me. They both despaired of ever killing the fish and set his weight at a dozen pounds at least. 'He'll take you all night, sir,' said Wisdom. 'Then I'll stop with him all night, if he does not break me for I never have been able to kill one of these big ones with a single hair,' was my reply. It had long been dark and he showed no signs of tiring, though he had in turn tired all of us. We hailed some men, several of whom having been attracted by the report of our having hooked a big 'un, were standing on the bank, to bring us a couple of lanthorns and some hot brandy... with the aid of the lanthorns we at length managed to get the net under the fish and lifted him out. I was disgusted to find that he was only a six and a half pound fish; it turned out that he was hooked by the back fin and his head being perfectly free he, of course, played as heavily as a fish of double the size...

The great difficulty with early lines whether horsehair or silk or, perhaps more commonly, a mixture of both, was that if left damp after a fishing outing they would soon rot. To prevent this, wooden line driers were built. Essentially a large skeleton frame on to which the line could be wound from the reel, the line winder allowed the line to dry quickly because it ensured that as the line wound over the drier it did not overlap itself. Line driers were made in dozens of shapes and sizes (some collapsible) but those by Hardy and Farlow are among the best. Names to look out for are the Bethune, the Practical, the Compact and the Hotspur.

Gut casts, made from the silkworm and imported in large quantities from Spain are also sought by some collectors

Improved Line Drier

In Use

374L.—Can be screwed to a table and the line unwound from the reel in a few minutes. The drum is 11 inches in diameter. It takes to pieces and packs into small space. A splendid and practical winder.

Price, in box, complete, **15/6**.

The "Ward" Line Drier

COLLAPSIBLE.

Made to the idea given to us by Dr. Ozier Ward.

This is a strongly made and handy line drier, which can be fixed to a table by means of the usual screw clamp. The arms are of hickory mounted with detachable wood pegs, upon which the line is wound. A milled nut with cushion spring is fitted on spindle end, and allows the tension to be regulated when winding line on to reel.

Packed in neat box, size 12 in. × 4 in. × 1¾ in.

Price **6/6** each.

Until the invention of nylon monofilament and the plastic fly-line, every angler needed a line drier: these two models were offered by Hardy in 1914.

simply because they were sold in attractive paper packets which still retain the maker's name and address, logo, and details about the cast's strength. Occasionally the packet will also include a motto announcing the superiority of that brand over any other.

Nylon only gradually replaced gut and as late as 1950 a correspondent writing to the magazine *Angling* expressed deep scepticism about the new material:

> I have never tried nylon as a substitute for the ordinary gut cast and am still loath to do so in view of the adverse criticism which it receives on account of its knot-slipping propensities. What angler wants to go to the trouble of sealing off every knot he ties? Mr Bays' idea of using a lighted match is a good one, but I suggest it would prove a tiresome thing to do at night – or with a fly! I have had a 4 lb trout on 4X ordinary gut – can nylon in a similar size handle such a fish without giving the angler heart failure!

Silk running lines, though not much in demand by collectors for their own sake, do fit the bill if you wish to keep an authentic-looking line on an old reel. They were imported in bulk from America and were available dressed – that is treated with an oil based preservative – or undressed. The latter lines had to be dressed by the fisherman, and many recipes were recommended by various authorities. Some writers recommended goose fat, others liquid paraffin and resin. Most such dressings would also include paint to produce the required dark green or brown colour.

Early priests, gaffs and brass spring balances which include some indication of the maker's name are rare items, but nineteenth century examples were occasionally made as gifts and they may be engraved with maker's and/or recipient's names. They are eminently collectable. Early priests in dark, heavily varnished turned wood appear from time to time and companies as eminent as Hardy's made fine examples – a wooden priest first appears in the

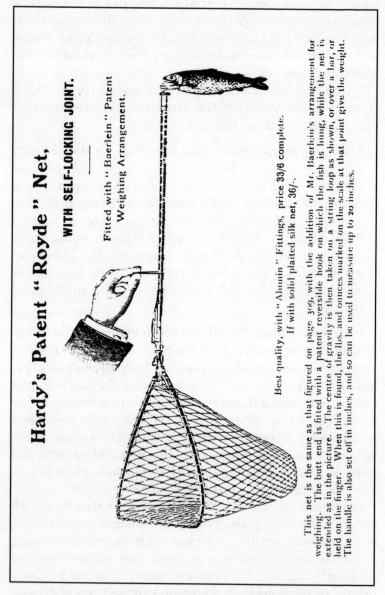

Hardy's Patent "Royde" Net,

WITH SELF-LOCKING JOINT.

Fitted with "Baerlein" Patent
Weighing Arrangement.

Best quality, with "Alumin" Fittings, price 33/6 complete.
If with solid plaited silk net, 36/-.

This net is the same as that figured on page 309, with the addition of Mr. Baerlein's arrangement for weighing. The butt end is fitted with a patent reversible hook on which the fish is hung, while the net is extended as in the picture. The centre of gravity is then taken on a string loop as shown, or over a bar, or held on the finger. When this is found, the lbs. and ounces marked on the scale at that point give the weight. The handle is also set off in inches, and so can be used to measure up to 20 inches.

The Victorians and Edwardians loved gadgets, but it is difficult today to assess just how popular an item like this combination net and weighing scales – from 1905 – would have been.

Hardy catalogue in the 1920s although in 1908 the company advertised a combination metal priest and balance. The balance, to weigh 40 lb by ½ lb, had a metal cover which was screwed off when you wanted to weigh your fish. The cover itself, when screwed back on to the handle, was heavy enough to act as an excellent priest.

Other Hardy accessories included clearing rings, disgorgers, trolling-rod rests, eel spears, the Dry Fly Angler's Knife (with tweezers), bait kettles and even whale harpoons!

Landing nets are well worth the attention of the collector. Early examples would have a whalebone or iron hoop at the end of a solid or hollow piece of bamboo or turned wood, but by the end of the nineteenth century folding examples were being made as well as telescopic-handled nets and combination nets with a weighing balance at one end or a hollow handle to take spare rod tops. The same is true of early gaffs, with their brass and iron hooks and hollow bamboo or turned handles. Some gaffs were made with telescopic brass handles. Both nets – particularly if their fine silk or cord meshes have survived – and gaffs make a wonderful addition to any collection of angling equipment.

The accessory that most typifies American fishing tackle must be the artificial lure, particularly the plug and spinner. The Americans, with a wider range of carnivorous freshwater species and with much more water to fish, did not need to develop so strictly the fly-fishing rules of etiquette that exist on most British trout waters. In America it was and is quite permissible in many areas to fish for largemouth bass, pike and even trout with a wide range of artificial lures, rather than with fly, and as the level of interest in fishing grew in America during the nineteenth century an increasing number of companies made plugs and spinners. Some of these are wonderfully detailed and well made with mother of pearl blades and intricate carving. Many are marked with the maker's name.

Dry Fly Requisites.

Waistcoat Pocket Fly Oil Bottle.

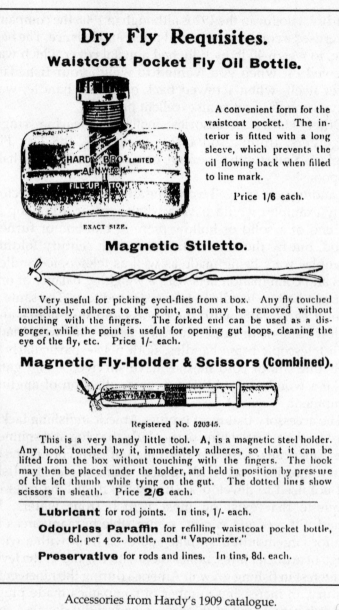

A convenient form for the waistcoat pocket. The interior is fitted with a long sleeve, which prevents the oil flowing back when filled to line mark.

Price 1/6 each.

EXACT SIZE.

Magnetic Stiletto.

Very useful for picking eyed-flies from a box. Any fly touched immediately adheres to the point, and may be removed without touching with the fingers. The forked end can be used as a disgorger, while the point is useful for opening gut loops, cleaning the eye of the fly, etc. Price 1/- each.

Magnetic Fly-Holder & Scissors (Combined).

Registered No. 520345.

This is a very handy little tool. A, is a magnetic steel holder. Any hook touched by it, immediately adheres, so that it can be lifted from the box without touching with the fingers. The hook may then be placed under the holder, and held in position by pressure of the left thumb while tying on the gut. The dotted lines show scissors in sheath. Price **2/6** each.

Lubricant for rod joints. In tins, 1/- each.

Odourless Paraffin for refilling waistcoat pocket bottle, 6d. per 4 oz. bottle, and " Vapourizer."

Preservative for rods and lines. In tins, 8d. each.

Accessories from Hardy's 1909 catalogue.

70

American fish decoys – a skill the European settlers learned from the native American peoples – are much sought after and like American duck decoys, the finest examples command extremely high prices. They were made in wood, bone and ivory.

Nineteenth-century tin livebait can.

ALL GOODS GUARANTEED.

Bark-tanned waterproof fishing stockings
from a late nineteenth-century newspaper advertisement.

5

STARTING
A COLLECTION

Many collectors of antique fishing tackle are happy with a
few rods, a few reels and whatever other bits and pieces
take their fancy; they buy as and when they can. There is
nothing wrong with collecting in this way – indeed it has
many advantages, including the fact that the collector may
gradually build up one or more complete fishing outfits,
which may include rod, net, creel, line, cast and flies, even
waterproofs and wading trousers. This creates an interest-
ing historical perspective since the collector will have a
more complete view of the past for the individual coarse- or
fly-fisherman.

However, as our knowledge of the subject increases, the
trend is most definitely away from general collections
towards specialisation. Collectors are increasingly attracted
by particular areas of their subject: thus a wealthy collector
of reels might concentrate exclusively on Hardy models
while a collector of more modest means might go for early
fixed spools or wooden Nottingham reels. Those who spe-
cialise in rods might concentrate on greenheart and hickory
or other early rods, while others might collect only trout
rods, or salmon rods, by great makers like Hardy's or
Farlow's.

The fact is that when it comes to collecting, there is an

almost unlimited number of possibilities, but it is a good idea to go for an area that has not so far been heavily exploited: you could, for example, collect reels or rods by less well-known or even anonymous makers or, if that seems too specialised and limiting, you could stick to accessories. These tend to be less expensive than rods and reels – you can pick up a splendid selection of fish kettles, nets, bags, priests, line driers and so on for much less than it would cost to buy one or two good reels.

Just about every antique shop in the country will have an item of fishing tackle for sale at some time or another, so it's well worth keeping an eye open for occasional windfalls of this kind, but few specialise. Simon Brett, based in Stroud, Gloucestershire is an exception. He deals entirely in fishing tackle and normally has a very wide range of top-quality items. Other dealers advertise regularly in the fishing press.

Buying from a dealer is a good idea if you want to be sure (so far as is possible) that an item is authentic, but dealers have to make a living and they are therefore likely to be more expensive than, for example, an auction.

Auctions are undoubtedly the richest source of old tackle and with care you should be able to buy for less than you would pay a dealer. However, auctions take no responsibility for the condition of an item nor for its authenticity, so it is very much a case of let the buyer beware. And it is easy to make a mistake. I once bought an early Aerial reel at an auction, for example, which had been very cleverly repaired – I did not notice the repair for some days. The reel looks perfectly good, and I am more than happy to hang on to it, but it is not in original condition and is therefore not as valuable as I had thought.

That is just one example of a problem which exists and not just with antique tackle. Skilled repairs and fakes can be extremely difficult to spot whether you collect longcase clocks, early furniture or fishing tackle and even experts with years of experience in all fields will make a mistake now and then.

Auctions

Local auctioneers will have occasional sales of fishing tackle, or they will include odd items of tackle in general sales, but the following hold regular sales of antique tackle:

Sotheby's, Old Bond Street, London W1

Christie's, King Street, St James, London W1

Bonhams, Montpelier Street, Knightsbridge, W1

Evans and Partridge, Agriculture House, High Street, Stockbridge, Hants

Apart from their London auction rooms, Sotheby's and Christie's have regional offices where tackle sales are also held. Both houses publish regular diaries of forthcoming sales covering the whole country and these are available from their London offices.

When you buy at auction you will have to add 10, 12 or 15 per cent to the cost of any successful bid – this is the auctioneer's premium – and if, like me, you have a tendency to get carried away when you can't bear to miss a particular item, then leave a commission bid. The auctioneer will then bid for you. This means that you leave a slip with the auctioneer telling him the maximum you are prepared to bid for a particular item. And as you then have no need to attend the auction in person you cannot exceed your stated maximum. It may all sound a bit complicated, but it works quite well and you will often get your rod or reel for less than your maximum price. Half the fun of collecting old tackle is the business of buying at auction – nothing gets the adrenalin going in quite the same way!

Dealers

Jamie Maxtone Graham, Freepost, Lyne Haugh, Peebles, Scotland EH45 8HP.

Brindley John Ayres, 45 St John's Road, Hakin, Milton Haven, Pembrokeshire SA73 3LJ.

Neil Freeman, PO Box 2095, London W12 8RU.

Simon Brett, Creswyke House, High Street, Moreton-in Marsh, Glos.

RECENT PRICES AT AUCTION

The following items were all sold at auction in recent years and though the list is by no means fully comprehensive it will give the newcomer to collecting a reasonable idea of what he or she must expect to pay for everything from a nineteenth-century landing net through the various rods, reels, lines, flies and creels, to the top-flight salmon- and trout-fly reels by Hardy's.

The prices given are hammer prices to which the auctioneer's commission (usually 10, 12 or 15 per cent) should be added. It is worth remembering too that most auctions of antique tackle will include a number of made-up lots, that is lots containing two, three or even half a dozen low cost items like cast wallets, line winders or occasionally even cheaper, anonymous reels.

Hardy reels, particularly Perfects, can be a minefield for the novice because prices will vary enormously according to the rarity of a particular size/check style combination and according to the amount of original finish – Hardy reels were given a special bronze coating which time invariably wears away, except in a few rare instances.

Hardy oak-framed display case of 24 various patterned salmon flies, 1930s: £170
French wicker and leather trout creel, 1930s: £85
Young's Ambidex No 2 fixed spool reel and two other Ambidex reels: £50
Hardy St John 3⅞ in. trout fly reel in original box: £80
Nineteenth-century brass narrow drummed winch with bone handle, c1850: £90

Illingworth No 1 2nd model threadline reel in original case, *c*1908: £950

Early nineteenth-century brass line twister, *c*1820: £240

Eighteenth-century iron spike winch, 3 in. diameter, with original horsehair line, *c*1740: £500

Nineteenth-century 2½ in. brass clamp winch with rose-wood handle, *c*1840: £340

Jones of London brass winch, 3½ in. diameter with ivory handle, *c*1850: £620

Copper and silver plated big game spoon 9¼ in. long, *c*1925: £120

H.L. Leonard three piece split cane fly-rod, nickel silver ferules, 9 ft 2 in., spare tip and cane tube: £80

Black japanned fly reservoir, containing seven lift-out trays and a quantity of gut-eyed salmon flies: £400

Hardy No 3 angler's knife: £190

An 'Expert' No 3 multiplying reel: £200

A 3⅜ in. Perfect trout-fly reel and a similar 3⅛ in. Perfect trout-fly reel: £110

G. Little & Co 7 piece cane combination fly/spinning travelling rod, in brass-capped bamboo tube: £360

Sextile type collapsible line drier, green enamel finish, 1950s: £32

Nineteenth-century brass single drawer salmon gaff: £28

D. Slater walnut and brass 4½ in. combination reel: £70

Allcock Commodore 6 in. alloy big game reel and a Pfleuger Pakron sea centre pin reel: £45

Hardy Altex No 3 Mk V salmon spinning reel in original box, *c*1950: £85

Allcock Felton Crosswind junior threadline reel: £34

Nineteenth-century 2½ in. brass winch with bone handle, and a 3½ in. brass plate wind salmon-fly reel with horn handle: £65

Dee Ghillie salmon landing net with elm handle and original net: £90

Hardy 3 piece dapping rod (2 tips), whole bamboo green-heart, 15 ft, in original bag: £48

Hardy Perfection 2 piece cane trout-fly rod, 10 ft: £65

Hardy Wye 3 piece (2 tips) cane salmon-fly rod, 12 ft 6 in.: £180

Hardy Combination 2 piece cane/greenheart rod: £120

Farlow 3¾ in. brass salmon-fly reel with bone handle, c1880: £140

J.B. Moscrop 4½ in. bronzed brass salmon-fly reel with ivory handle, c1900: £95

A.J. Gillett whole bamboo and greenheart salmon-fly rod, 3 piece (2 tips), 11 ft, c1880: £80

Hardy Phantom 2 piece cane trout-fly rod, 9 ft, in bag: £90

Facile 4 in. ebonite centrepin reel with brass starback, 1920s: £48

A rare Percy Wadham 'The Cowes' 4 in. alloy combination reel with twin ivorine handles, c1928: £220

Milward's mahogany and brass 4½ in. Nottingham star back reel and two other Nottingham reels: £48

Hardy St George 3½ in. trout-fly reel, 1950s: £55

Hardy Perfect 3¾ in. salmon-fly reel, 1930s: £220

Hardy Decantelle 2 piece cane salmon spinning rod, 10 ft, c1922: £38

J. Bernard & Son 3 piece (4 tips) greenheart salmon fly rod, c1880: £60

Hardy 4½ in. all brass Perfect salmon-fly reel in original condition, c1891: £3,400

Rectangular 'rexine' coarse fisherman's wallet, fitted interior with float and line winder, c1910: £65

Mitchell Albatross oval zinc bait kettle with perforated liner and swing handle: £25

Chromed brass two drawer salmon gaff with turned wooden handle, 1930s: £35

Rare Hardy brass crank wind 4 in. salmon-fly reel, c1885: £240

Pfleuger Alpine nickel silver big game multiplier, 1930s: £42

Allcock Aerial 4 in. alloy centre pin reel, c1925: £160

Haywood 2½ in. brass multiplying winch with bone handle, c1840: £240

Nineteenth-century steel gut twisting table and a bottle of Hardy preserved prawns: £35

Hardy Rogue River 3 piece (2 tips) cane trout-fly rod, 1950s: £65

Hardy Perfect 3⅞ in. alloy trout-fly reel, c1920: £130

Rare Slater Ideal 3 in. alloy combination fly/spinning reel with twin horn handles, c1900: £50

Nineteenth century fruitwood bank runner with turned decoration on tapered spindle: £55

Malloch brass 4 in. salmon-fly reel in original box, c1930: £80

Hardy St John 3⅞ in. trout fly reel, in original box, c1930: £80

Hardy Silex No 2 extra wide drummed 4½ in. bait-casting reel in original leather case, c1910: £180

A large collection of mainly American wooden plugs: £130

24 fully dressed classic gut-eyed salmon flies: £100

Hardy Decantelle 2 piece greenheart salmon spinning rod, 10 ft: £32

A.J. Bernard & Son 3 piece (2 tips) hickory salmon-fly rod, 17 ft, c1890: £42

Forrest & Sons 3 piece (2 tips) spliced greenheart salmon-fly rod, 15 ft, c1880: £35

Hardy brass-faced Perfect (4¾ in.) salmon-fly reel with almost all original bronze finish, c1908: £1,150

Early Hardy Altex No 2 fixed spoon reel in original 'rexine' case, c1930: £120

A rare Hardy St George Multiplier 3¾ in. trout-fly reel in original leather case, 1930s: £500

Nineteenth-century English plaited horsehair line: £60

Hardy Hydra 4⅜ in. alloy salmon-fly reel in original box, unused, 1950s: £55

Malloch 3 in. alloy trout-fly reel and a Beaulite alloy trout-fly reel: £40

Hardy Silex 3¾ in. alloy bait casting reel, c1906: £110

Hardy Super Silex 4½ in. extra wide drummed alloy bait casting reel, 1930s: £320

Hardy Sunbeam 3¾ in. alloy trout-fly reel with original finish, 1930s: £42

Hardy bamboo rod tube with leather cap, 1930s: £38

Farlow & Co 3 piece greenheart salmon-fly rod, 15 ft, with bronze snake rings, c1890: £48

Hardy Compact line drier with folding alloy arms and ebonised handle: £38

Allcock Aerial Popular 4 in. alloy centre pin reel, c1930: £75

A.J. Bernard & Son 5 in. brass plate wind salmon reel, c1890: £70

Rare Milward's frog-back mahogany and brass 6 in. Nottingham reel, c1910: £140

Army & Navy leather trout-fly wallet, a cast wallet, a leather trout-fly wallet and a beechwood otter: £28

Nineteenth-century black Japanned gentle (maggot) chute of tapered, conical form and a perforated brass circular bait box: £70

A pair of Edwardian canvas and leather wading brogues and matching canvas stockings: £30

An Illingworth No 4 Mk II Threadline reel, c1935: £95

An Allcock match special 4 in. narrow drum trotting reel and a Speedia 4¼ in. trotting reel: £60